HISTORIC PHOTOS OF BROOKLYN

TEXT AND CAPTIONS BY JOHN B. MANBECK

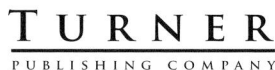

This view of the Brooklyn Bridge, the "eighth wonder of the [modern] world," from the Brooklyn side shows a steamboat passing under the span, with the ferry house and a firehouse at left.

HISTORIC PHOTOS OF
BROOKLYN

Turner Publishing Company
200 4th Avenue North • Suite 950
Nashville, Tennessee 37219
(615) 255-2665

www.turnerpublishing.com

Historic Photos of Brooklyn

Copyright © 2008 Turner Publishing Company

All rights reserved.
This book or any part thereof may not be reproduced or transmitted in any form or by any means, electronic or mechanical, including photocopying, recording, or by any information storage and retrieval system, without permission in writing from the publisher.

Library of Congress Control Number: 2007942095

ISBN-13: 978-1-59652-435-4

Printed in the United States of America

08 09 10 11 12 13 14—0 9 8 7 6 5 4 3 2 1

CONTENTS

ACKNOWLEDGMENTS .. VII

PREFACE ... VIII

BROOKLYN IS AMERICA
 (1852–1899) ... 1

A NEW AGE
 (1900–1929) ... 45

BROOKLYN'S GLORY DAYS
 (1930–1949) ... 115

ON THE BRINK, ON THE RISE
 (1950–1982) ... 171

NOTES ON THE PHOTOGRAPHS ... 201

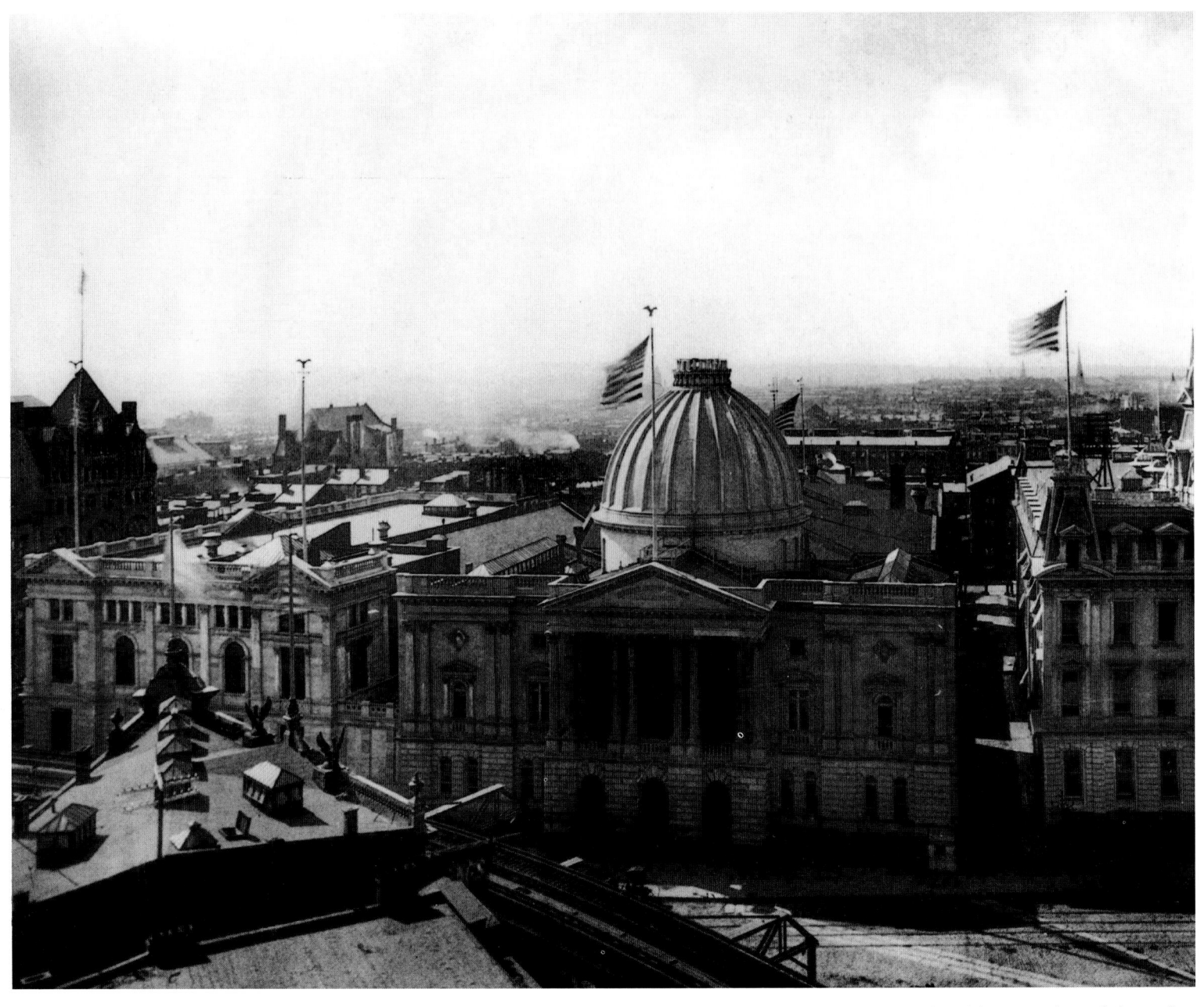

As viewed from the roof of Brooklyn City Hall in 1891, the Kings County Court House is flanked by the Municipal Building at right and the Hall of Records at left. Both flanking buildings were demolished in 1926 for a new Municipal Building.

Acknowledgments

With the exception of cropping images where needed and touching up imperfections that have accrued over time, no other changes have been made to the photographs in this volume. The caliber and clarity of many photographs are limited by the technology of the day and the ability of the photographer at the time they were made.

This volume, *Historic Photos of Brooklyn,* is the result of the cooperation and efforts of many individuals, organizations, and corporations. It is with great thanks that we acknowledge the valuable contribution of the following for their generous support:

Brooklyn Historical Society
Brooklyn Public Library—Brooklyn Collection
Kingsborough Historical Society
Library of Congress
New York State Archives

For assistance in researching photographs, I wish to thank Joy Holland of the Brooklyn Collection at the Brooklyn Public Library at Grand Army Plaza; Deborah Schwartz, president of the Brooklyn Historical Society; Julie May, photography archivist at the Brooklyn Historical Society; and Michael McCalip of Turner Publishing. In addition, we used the archives of the Library of Congress, New York State Archives, the archives of the Kingsborough Historical Society, my personal library of Brooklyn sources, and the Internet. My gratitude also goes to my favorite proofreader, Virginia B. Manbeck, who always had time to correct my syntax.

—*John B. Manbeck*

Preface

Brooklyn, a community analogous with Kings County since 1683. Brooklyn, an agrarian society until well into the twentieth century. Brooklyn, the peaceful western tip of Long Island, living in suburban solitude until the Brooklyn Bridge arrived. Brooklyn, a city unknown to the world until its raucous rebirth as a New York City borough. Brooklyn, discovered by millions as a welcome alternative to life somewhere else. Brooklyn, the magnetic attraction, the magical name.

Over the centuries, Brooklyn has drawn people for a magnitude of reasons. With land plentiful, Dutch settlers followed by British ones constructed manorial estates and settled on expansive farmland. The advent of the Industrial Revolution introduced enterprises such as printing, pottery, petroleum and refining, glassmaking, and iron foundries—collectively known as the "black arts" for the grime involved in the work—and international trade to the city's hospitable waterfront. As transportation improved, population growth and development altered remote sections of Brooklyn.

And the people! From embattled circumstances in other parts of the world, the self-possessed, opinionated Brooklyn character emerged, proud of his life yet provincial. He beckoned the intellectual. He became teacher and student, the musician and the listener. He delighted in the product of his old-world craft. He was the "wise guy" and the "hick"; the prosperous and the homeless. Crossing the new bridges, he and others descended on Brooklyn bringing with them a new enlightenment. They not only participated in this open community existence, but put Brooklyn on the map.

They labored in the new industries; rode the new trolleys, elevated railways, and subways; participated in entertainment, from street games to theater to new amusements; cheered ethnic parades and parades for children. Their languages became Brooklyn argot. Symbols of their American lives spread far and wide: the Fulton ferry, the Brooklyn Bridge, Flatbush Avenue, Prospect Park, Pitkin Avenue, Coney Island. Their patriotism and religiosity translated into the American spirit.

And then the rug was pulled from under them. At the end of World War II, the essence of their lives disappeared. The Brooklyn Dodgers baseball team left, the Navy Yard closed, the economy weakened; people turned bitter, moved away. The camaraderie vanished. Times were tough.

But Brooklynites were tougher. Those who stayed re-created Brooklyn with new goals. Newcomers took the edge off the old Brooklyn image. Formerly neglected areas reconstituted the borough. Brooklyn rediscovered itself, and the world took heed. Again, outsiders crossed those bridges and repopulated the borough. Tourists—those befuddled strangers who appeared in Thomas Wolfe's short story "Only the Dead Know Brooklyn"—received welcomed greetings. Open-topped buses prowled the streets, culture beckoned, new buildings rose tall and proud.

And Brooklyn was rewarded with a new dignity and grace as visitors and transplants surged back to fill Brooklyn Heights, Park Slope, Williamsburg, Brighton Beach, Sunset Park, Bedford-Stuyvesant, Cobble Hill, Clinton Hill, Bay Ridge, Midwood, Red Hook, and on and on and on.

It's a good life, this Brooklyn.

In this book, you will see the varied lifestyles of Brooklynites through parts of two centuries. The disparity of lives and neighborhoods becomes noticeable when studying the pictures. Yet there is majesty in the architecture—in government buildings, department stores, private clubs, even within the entertainment section of Coney Island. The natural environment offered a boon to those who developed and expanded Brooklyn—the parks, the formerly gated communities, the waterfront.

Just as long-time residents demonstrated their individuality, individuals gravitated to Brooklyn. Designers of bridges and parks, inventors, entrepreneurs, politicians and statesmen, clerics—even scalawags—lived and absorbed the Brooklyn environment. Throughout this book, the images show how average and exceptional people lived their lives while giving to and taking from the borough. While they interacted with their neighborhoods, the external world affected them as well: the wars, worldwide and regional; economic developments such as the recession that forced the city of Brooklyn to merge with the city of New York; racial tensions; and the implementation of government policies such as the new city charter and the federal closings of the Navy Yard and the Naval Air Station.

While Brooklyn competed on equal grounds with the island across the East River, it was Manhattan that received the glamour and attention. Unlike the Bronx, Queens, or Staten Island, Brooklyn had its own governmental superstructure for 273 years. That foundation made Brooklyn a strong adversary. This distinction holds today, making the study of Brooklyn's history intriguing.

Enjoy Brooklyn!

—*John B. Manbeck*

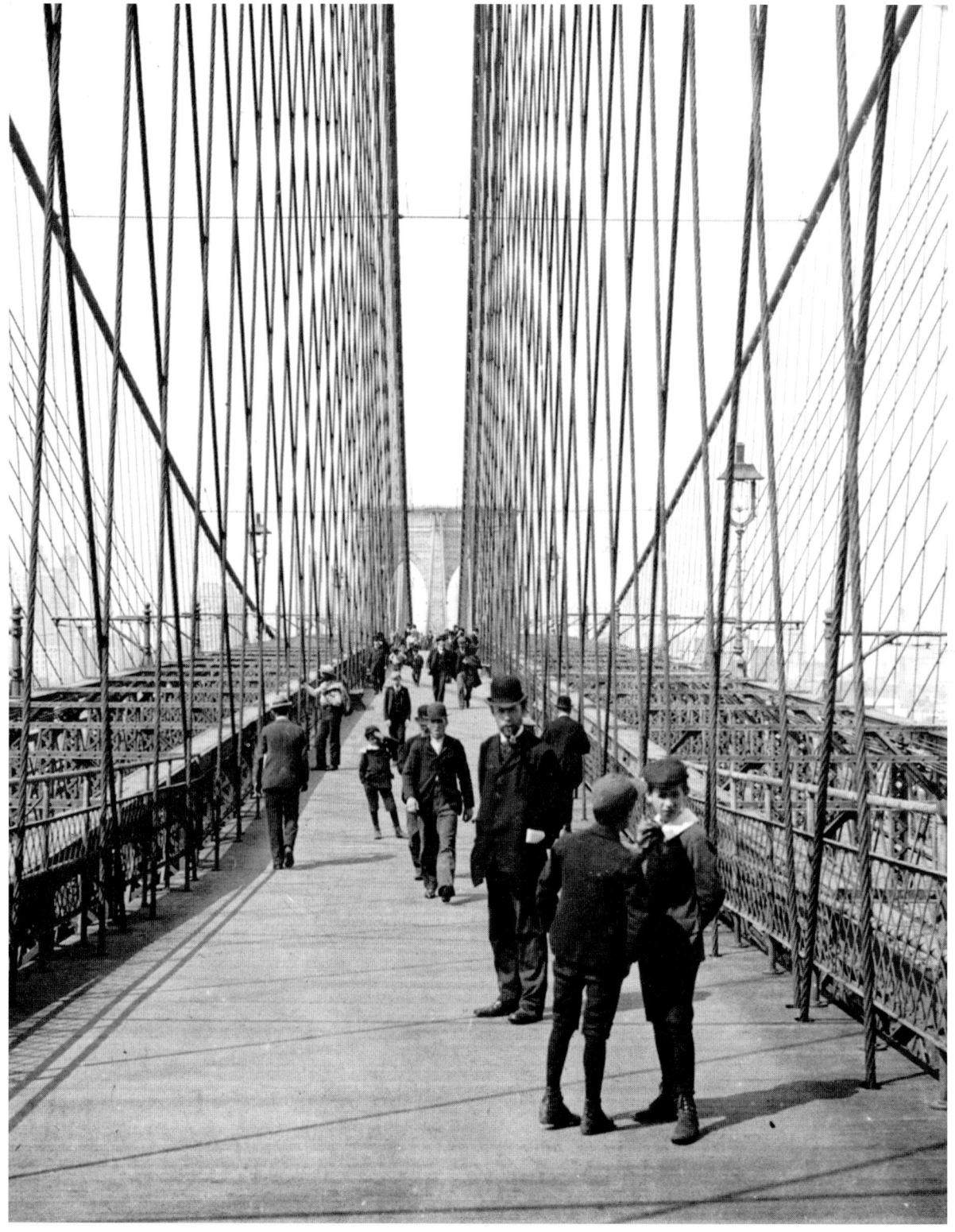

Popular since opening day when 150,300 people walked across it, the Brooklyn Bridge remains a favorite for walkers and bicyclists.

Brooklyn Is America

(1852–1899)

By 1852, the early immigrants to the cities of New York and Brooklyn—Dutch, English, and German—had settled in established communities. Dutch colonial rulers had encouraged intellectual freedom, while the British had resigned themselves to the upstart American spirit of independence that in 1776 erupted into the Battle of Brooklyn cry for liberty.

Both Brooklyn and New York continued operation of what the Dutch had instituted: an international commercial mercantile port. Before the Civil War, much of New York's commerce included trade with southern states that supplied products for New York's textile industry. Slaves had worked on Brooklyn's many farms and contributed to the transplanted Southern tradition of horse racing. New York State outlawed slavery in 1829.

During the Civil War, Brooklyn played a significant role, bolstering Union forces with its Navy Yard. The outspoken abolitionist Henry Ward Beecher, brother of the author Harriet Beecher Stowe, preached against slavery from his pulpit in the Church of the Pilgrims where President Abraham Lincoln once came to worship. The Brooklyn poet and editor Walt Whitman served as a nurse in the war.

As the war ended, Brooklyn expanded, with multiple railroad lines extending north to south from the city proper to Coney Island. Farmland was transformed into communities, and communities into neighborhoods. Fueling the expansion was a growing mercantile sector along the banks of the East River, supervised by an elite corps of entrepreneurial barons. As unions pressed for a shorter work week, leisure activities and venues emerged: Prospect Park, racetracks, baseball parks, theaters. Even Buffalo Bill arrived in Brooklyn with his Wild West Show.

Surely, the success of Brooklyn, bolstered by the access promised by a new bridge under construction over the East River, prepared the way for Brooklyn's annexation by New York City. In 1883, the opening of the Brooklyn Bridge completed the connection, and the immigrant masses descended on Brooklyn from Manhattan. Up in the state capital of Albany, legislative wheels turned to move the concept of a Greater New York City closer to reality. But before that borough consolidation could fuse, the Spanish-American War erupted with the destruction of the USS *Maine,* built in Brooklyn.

And then, to Brooklyn residents, the infamy of 1898: the city was reduced to a borough.

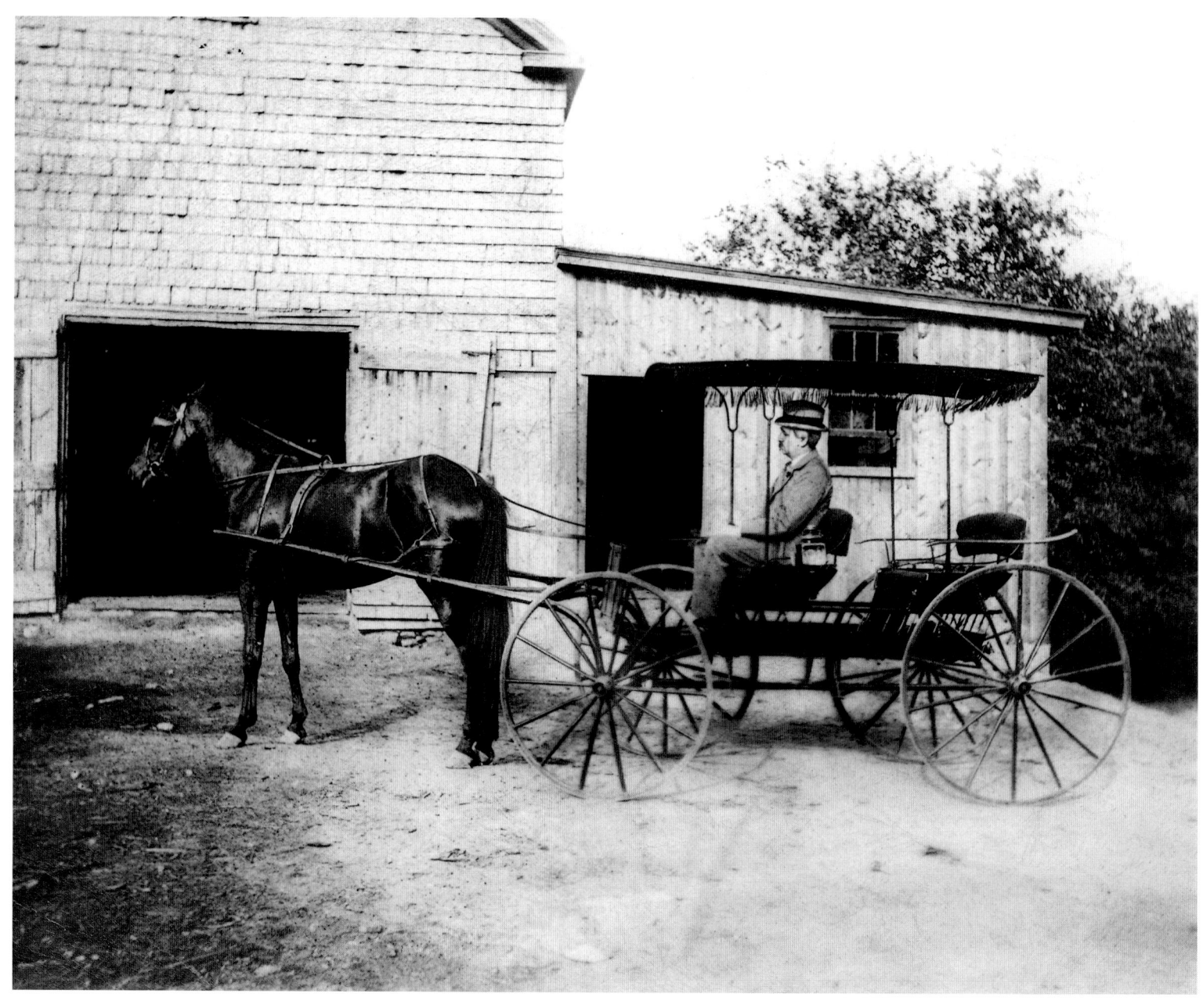

For most of the nineteenth century and into the twentieth century, Brooklyn remained agricultural, with horses a primary means of transportation. Here, a horse and carriage sits on a Brooklyn farm in the 1870s.

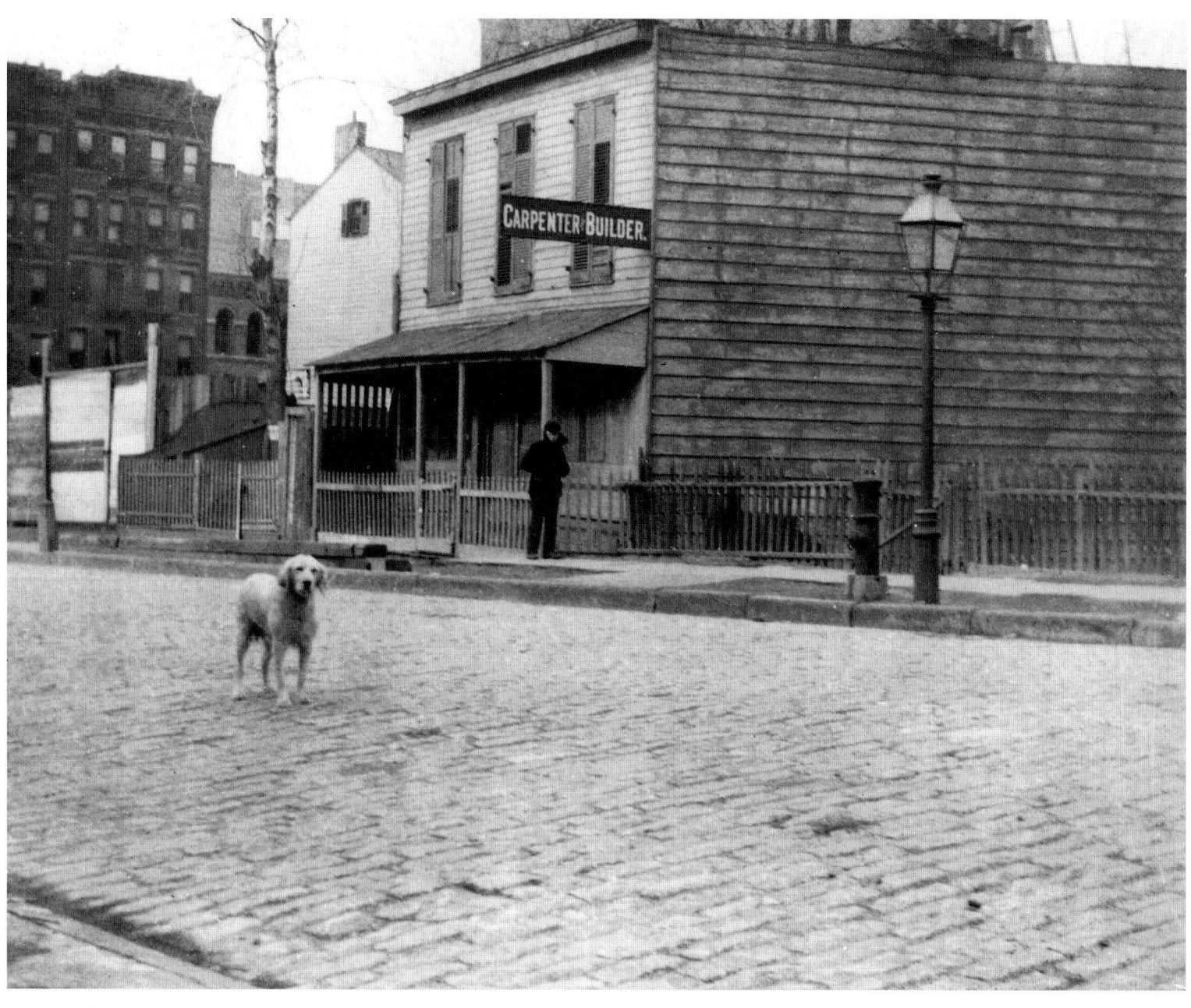
After editing the *Brooklyn Daily Eagle* in 1846, the bard of Brooklyn, Walt Whitman, held a variety of jobs, including building houses for this carpenter shop on Cumberland Street near Atlantic Avenue, before publishing his landmark poetry collection *Leaves of Grass* in 1855.

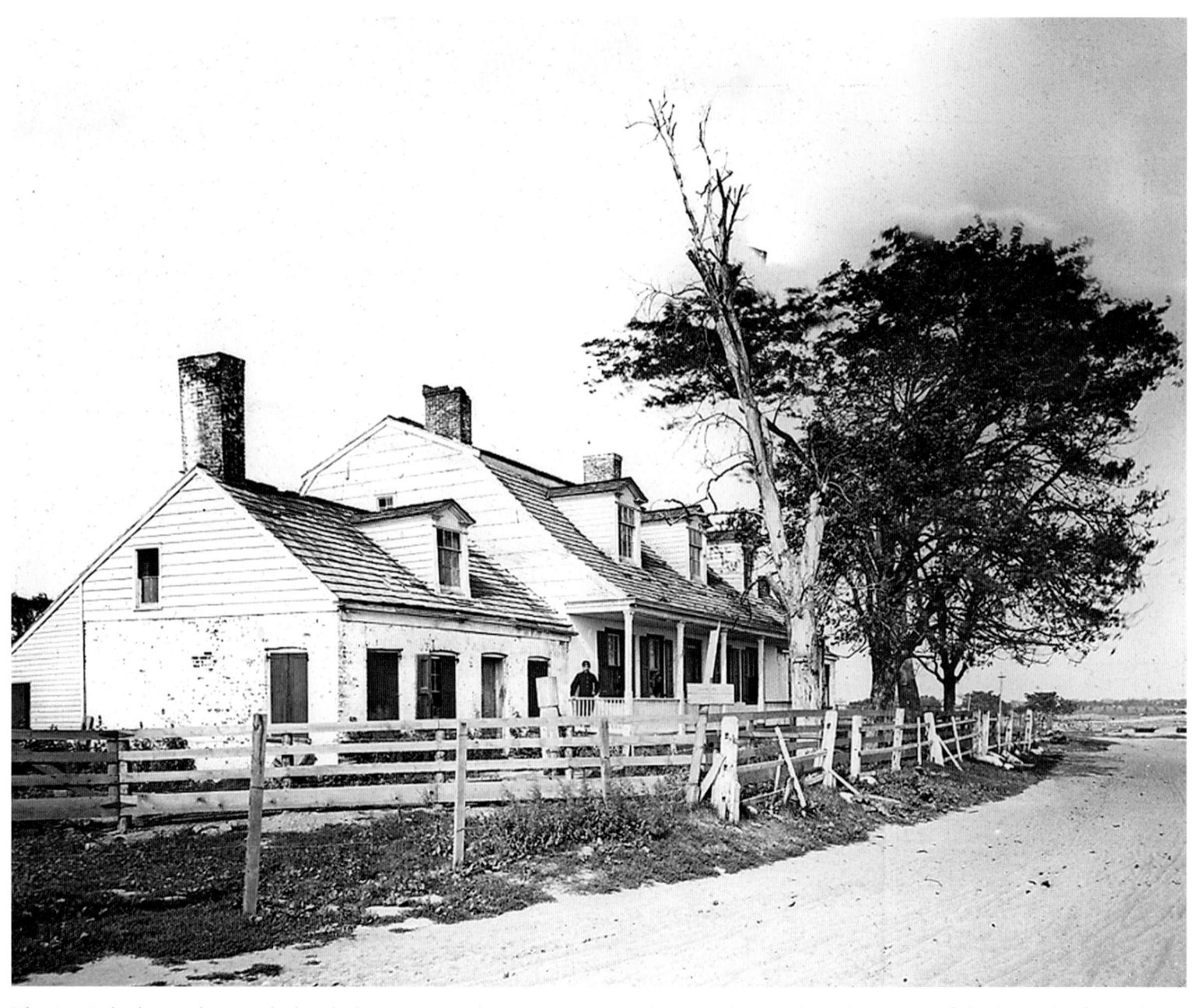
This Bay Ridge house photographed in the late 1800s stood near Denyse Ferry where British troops landed in 1776 to fight the Battle of Brooklyn.

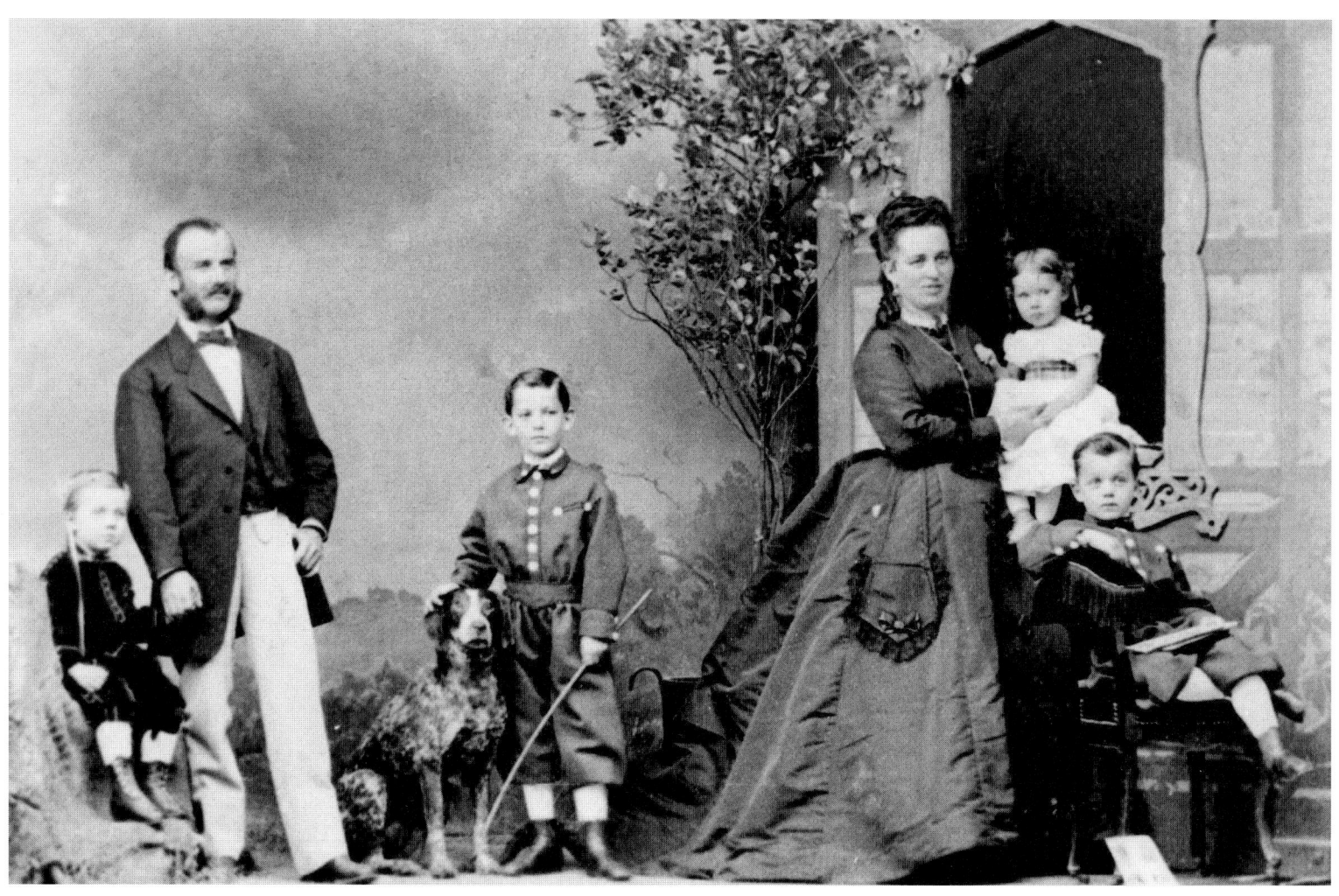

About 1870, when this family portrait was taken, Charles Pfizer, a German immigrant, had already successfully established his pharmaceutical company with Charles Erhart. Pfizer lived on Washington Street in Clinton Hill and supervised his Williamsburg business. By 1989, Pfizer was the only drug company that still manufactured in New York City.

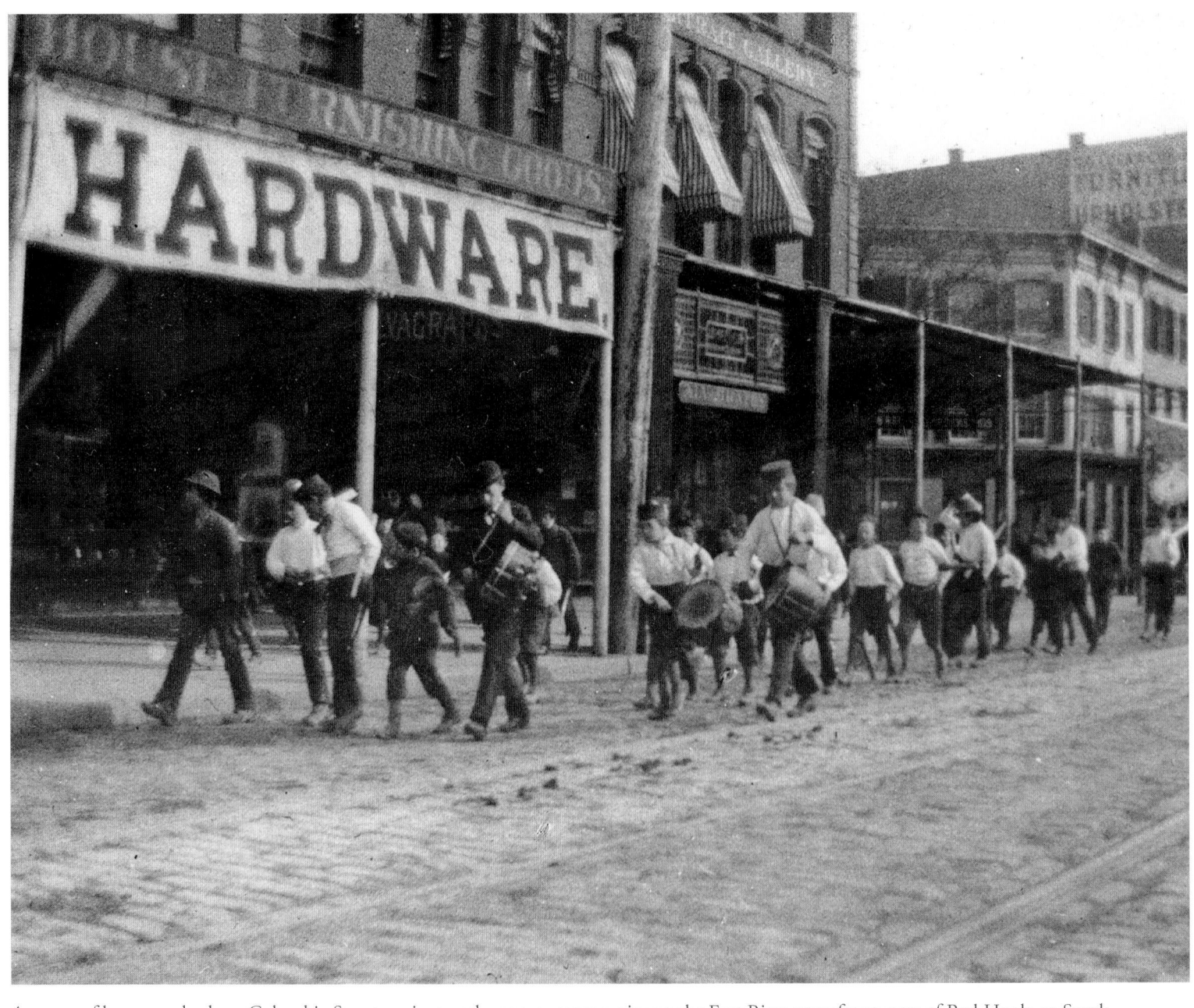

A group of boys parade along Columbia Street, a nineteenth-century community on the East River waterfront, part of Red Hook, or South Brooklyn, where working-class people lived.

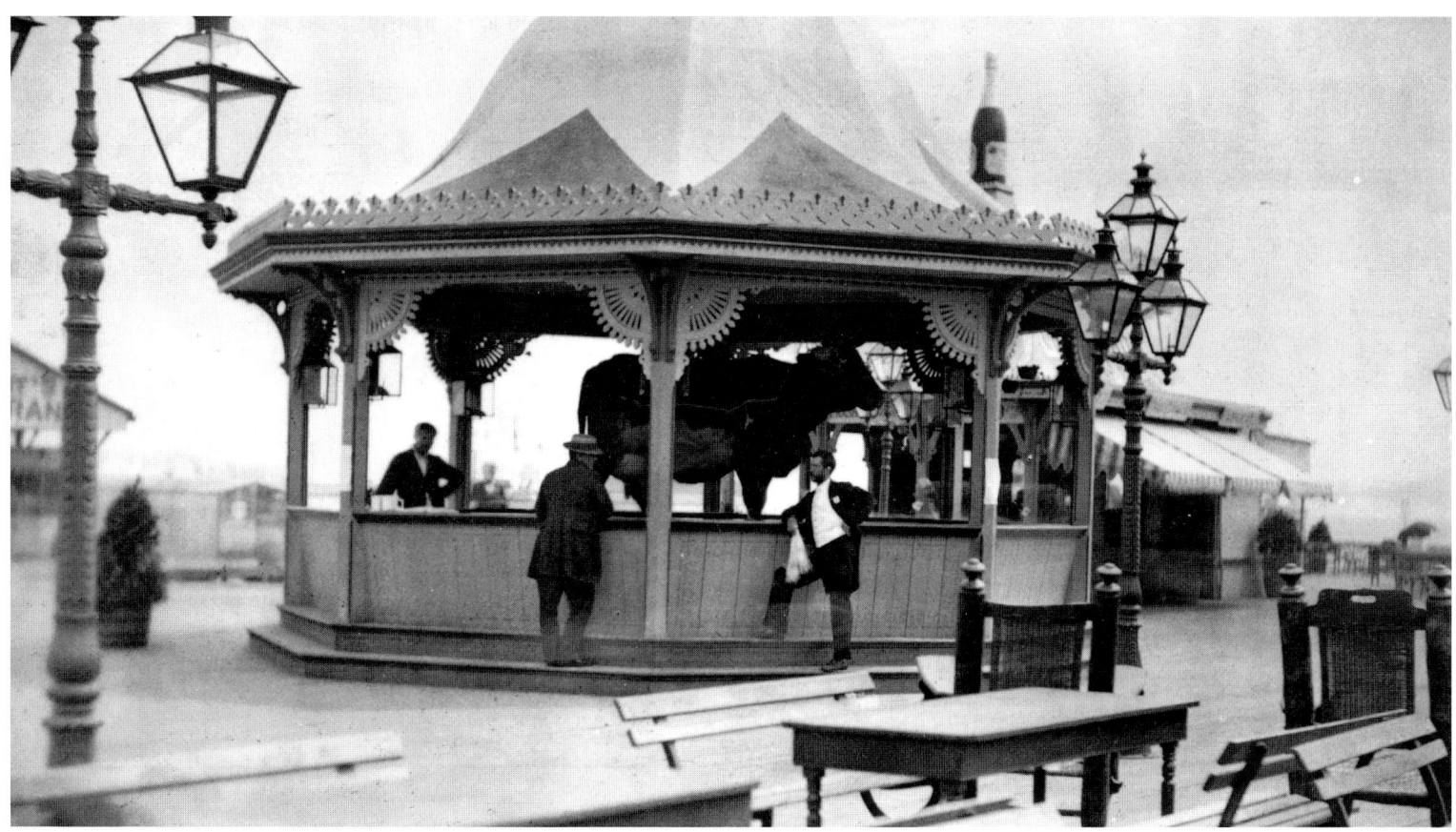

After the Civil War, the arrival of rail lines and hotels at the popular destination Coney Island spurred the development of rides and other amusements. Seen here about 1879, the Inexhaustible Cow was a Coney Island concession located between the Iron Pier and the Iron Tower where crowds of excursion visitors disembarked. The "maids" at the cow drew milk from one side, beer from the other.

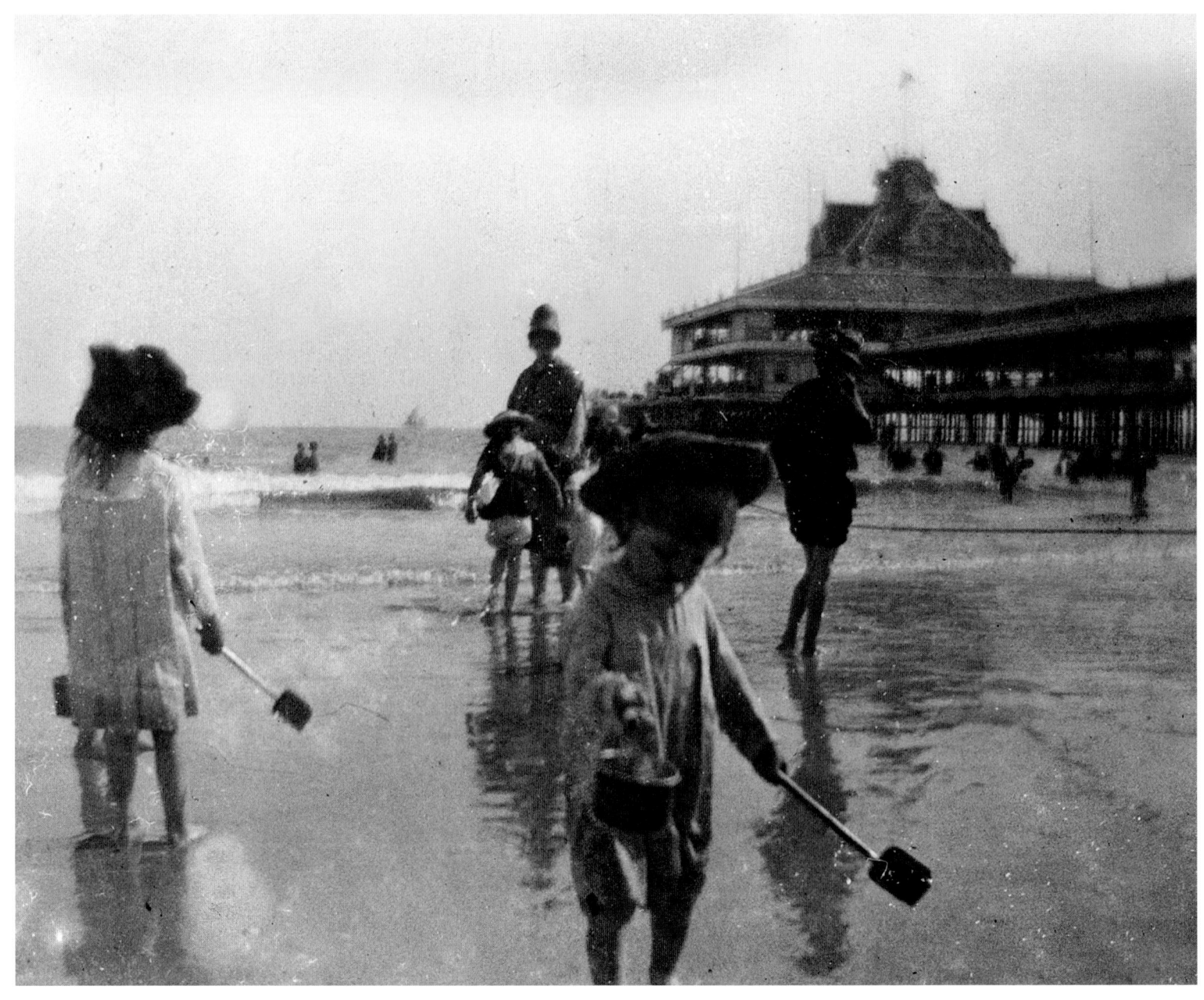

While interest in the Coney Island beach had more to do with clams than swimming, the two-storied Iron Pier built in the 1870s and seen at right provided a steamboat landing for excursions, a shopping center, and a safe haven for the sand-bucket brigade.

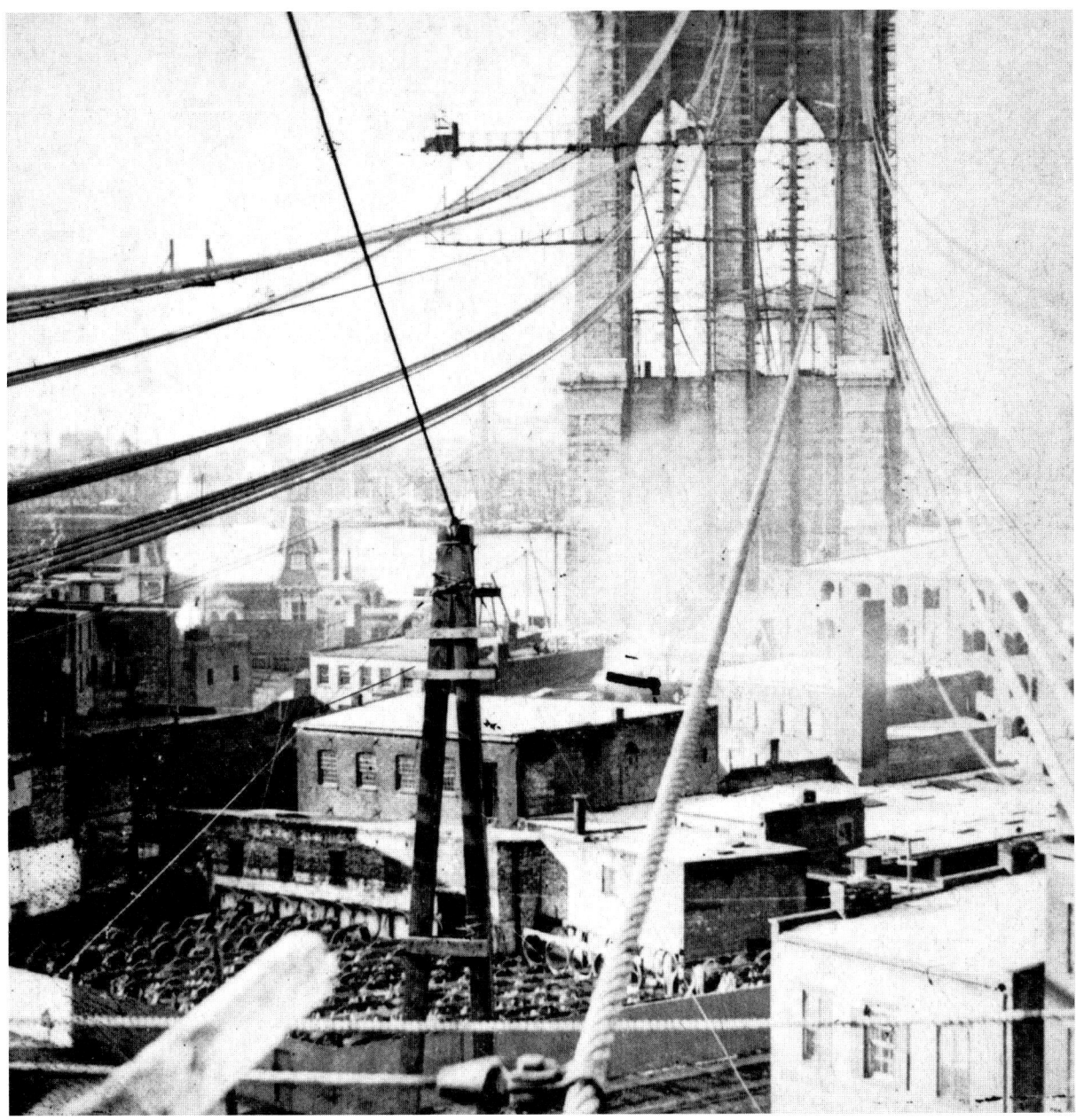

From 1870 until 1883, the Brooklyn Bridge was constructed amid constant threats and mishaps due to both the physically dangerous work and political opposition. Conceived by engineer John Roebling, the work was picked up by his son, Washington Roebling, after John's death, and then by Emily Roebling, Washington's wife, after Washington contracted the decompression illness known as the "bends" from working on the project and became bedridden.

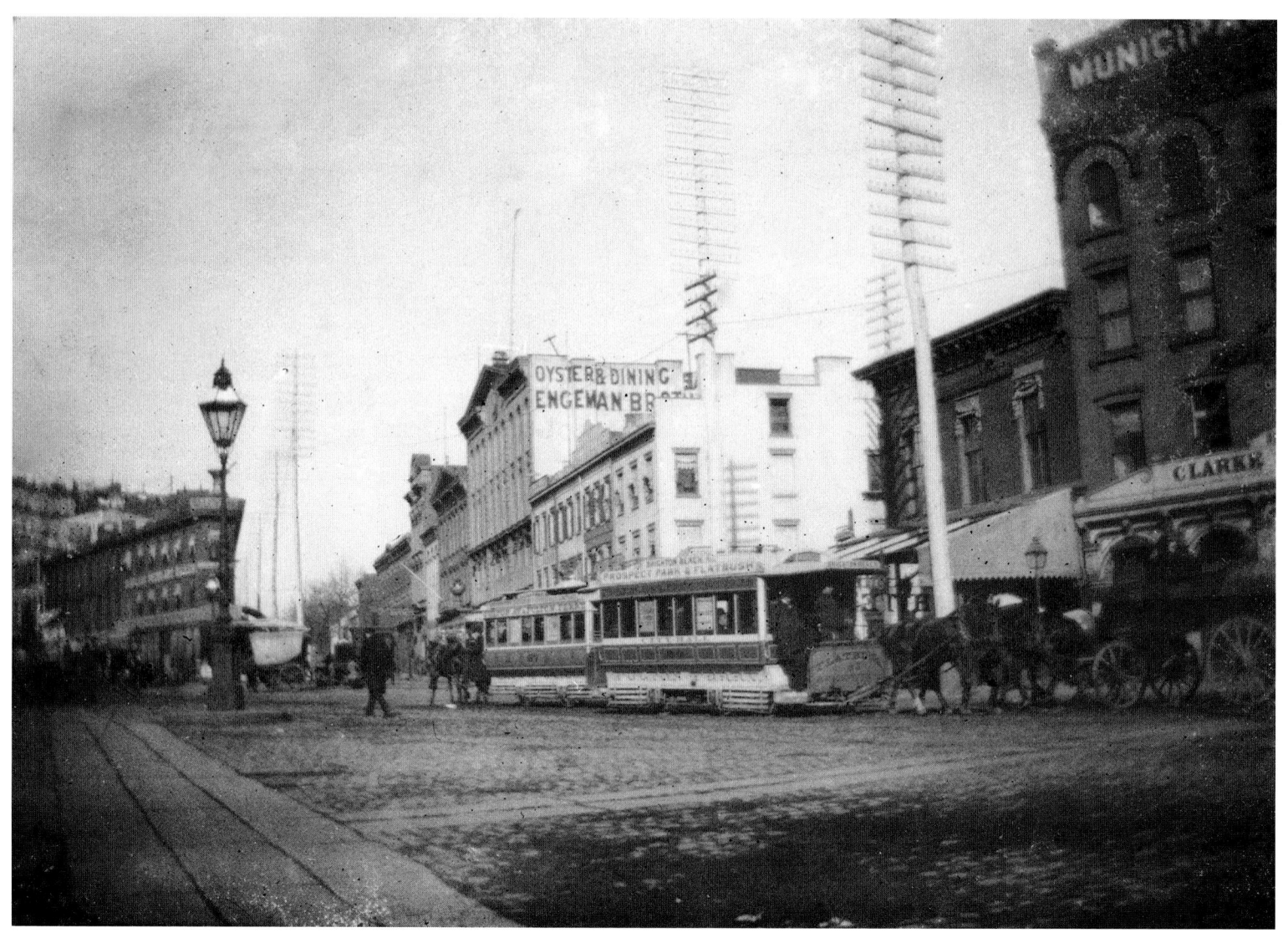

In this view of a busy Washington Street at the heart of what is now DUMBO—Down Under the Manhattan Bridge Overpass—when the district was a Brooklyn shipping center, note the advertisement for William Engeman's "Oyster Dining" at Brighton Beach. Engeman owned the Hotel Brighton.

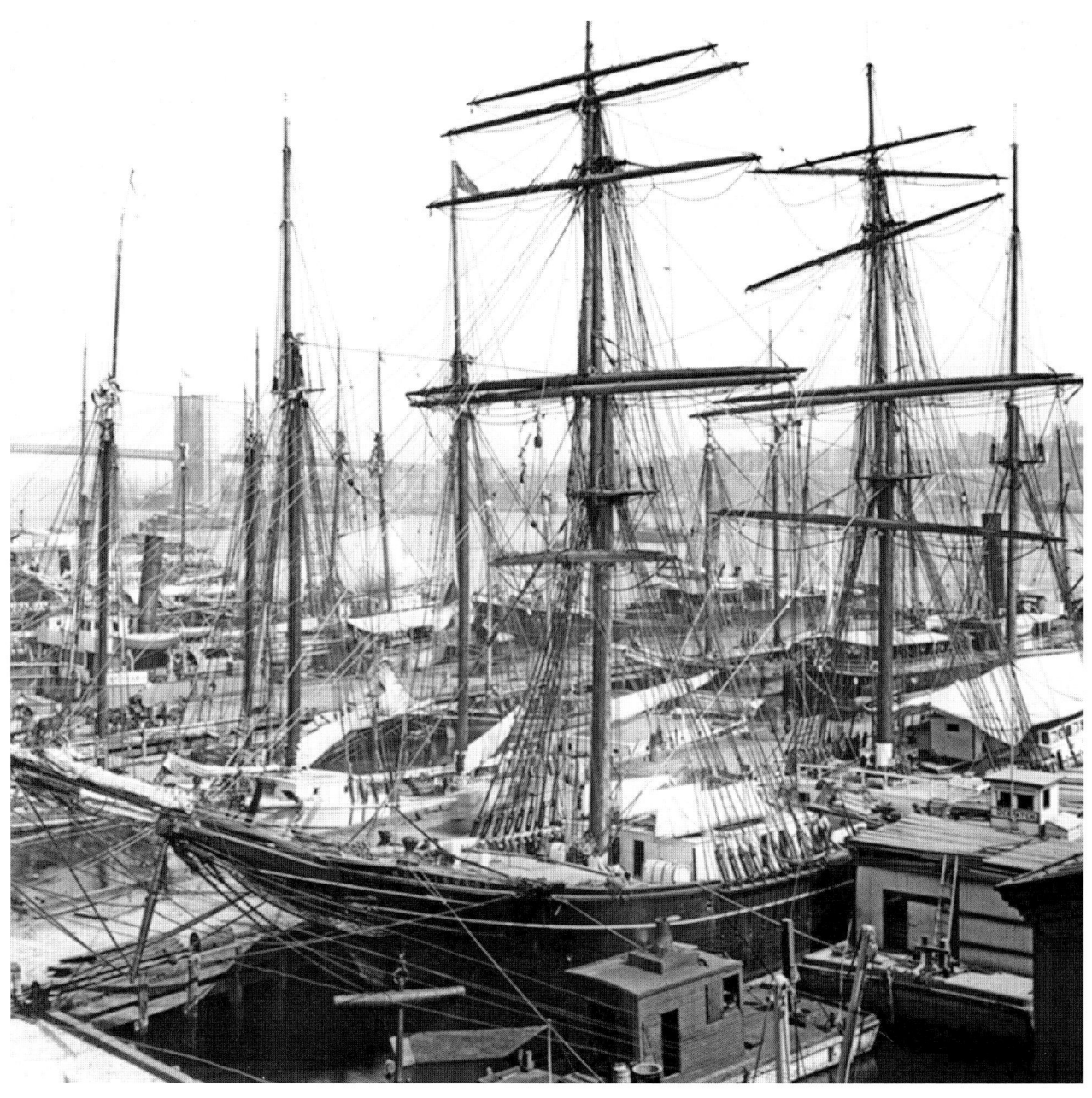
The Brooklyn Bridge can be seen in the distance from a busy nineteenth-century seaport on the Manhattan side of the East River.

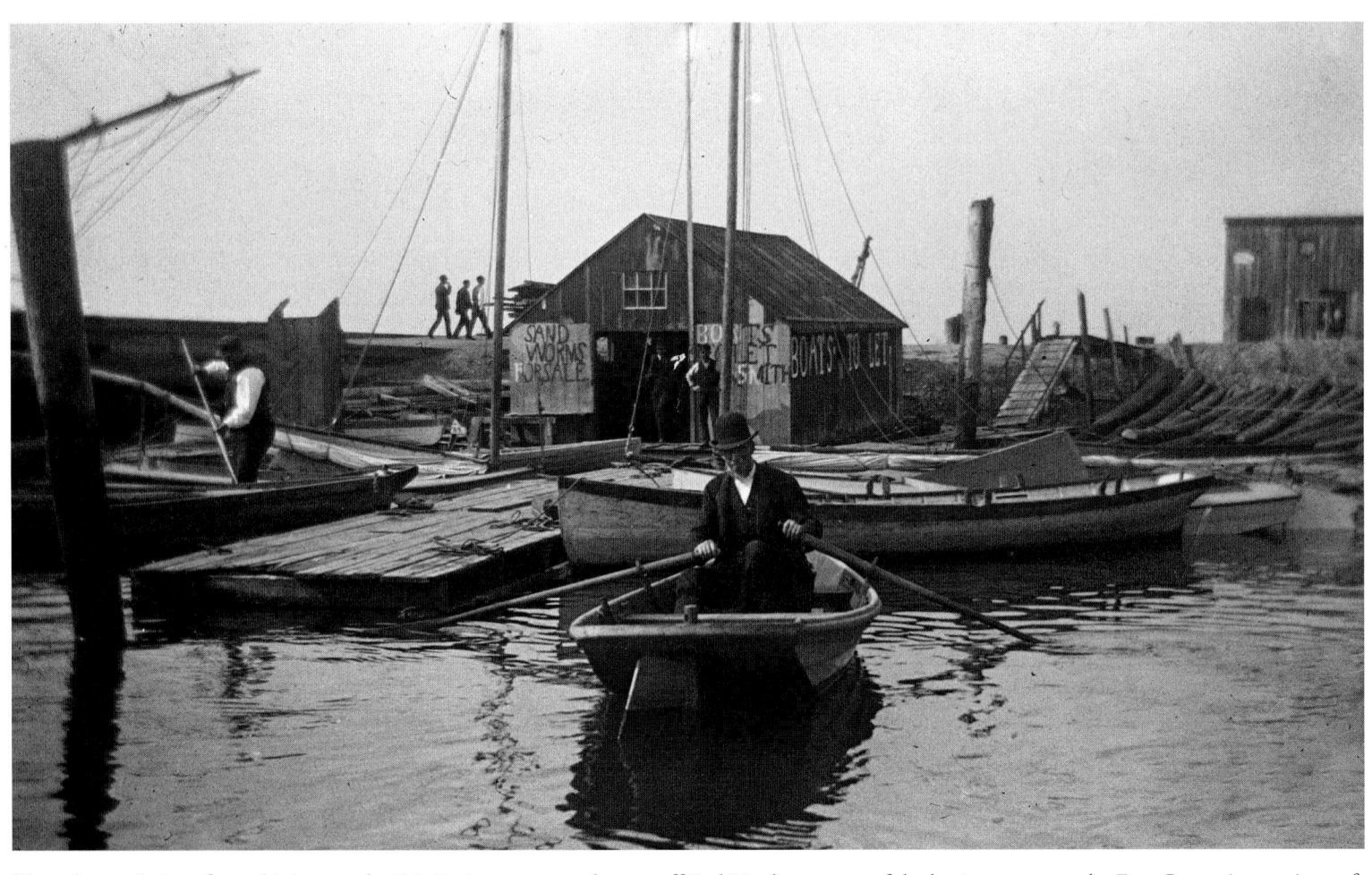

Though not obvious from this image, the Erie Basin, a man-made port off Red Hook, was one of the busiest ports on the East Coast. As terminus of the Erie Canal, the port built by Charles Beard specialized in grain-shipping from the Midwest and ship-repair facilities.

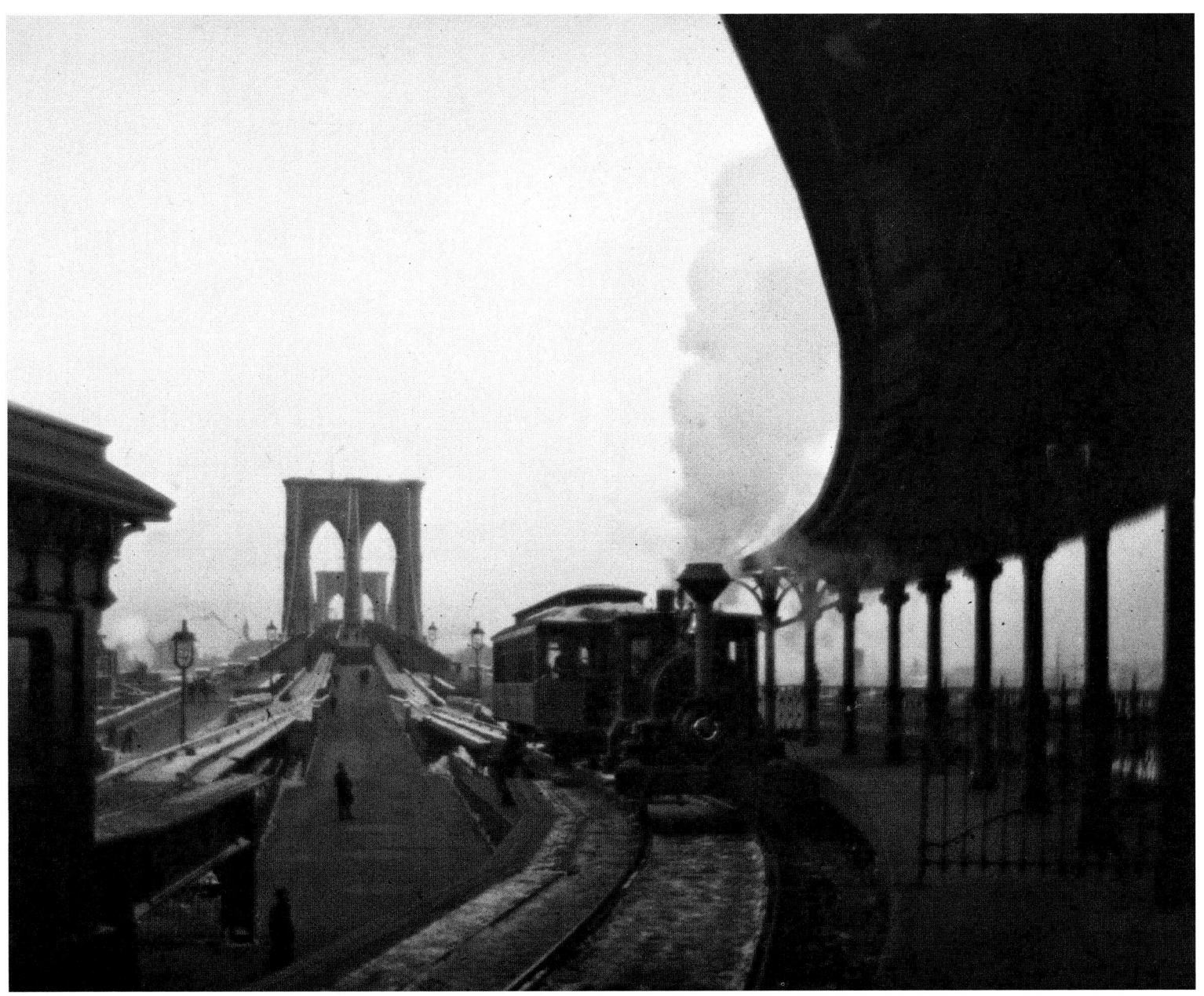
When Washington Roebling heard that trains would be crossing the Brooklyn Bridge, he strengthened the cables used to support the suspension. Nevertheless, a cable car was the first rail transportation across the bridge, but steam engines were substituted when bridge engineers proved Roebling's calculations correct. Trolleys started running in 1898 along with the trains. In 1944, trains were stopped, but trolleys ran until 1950.

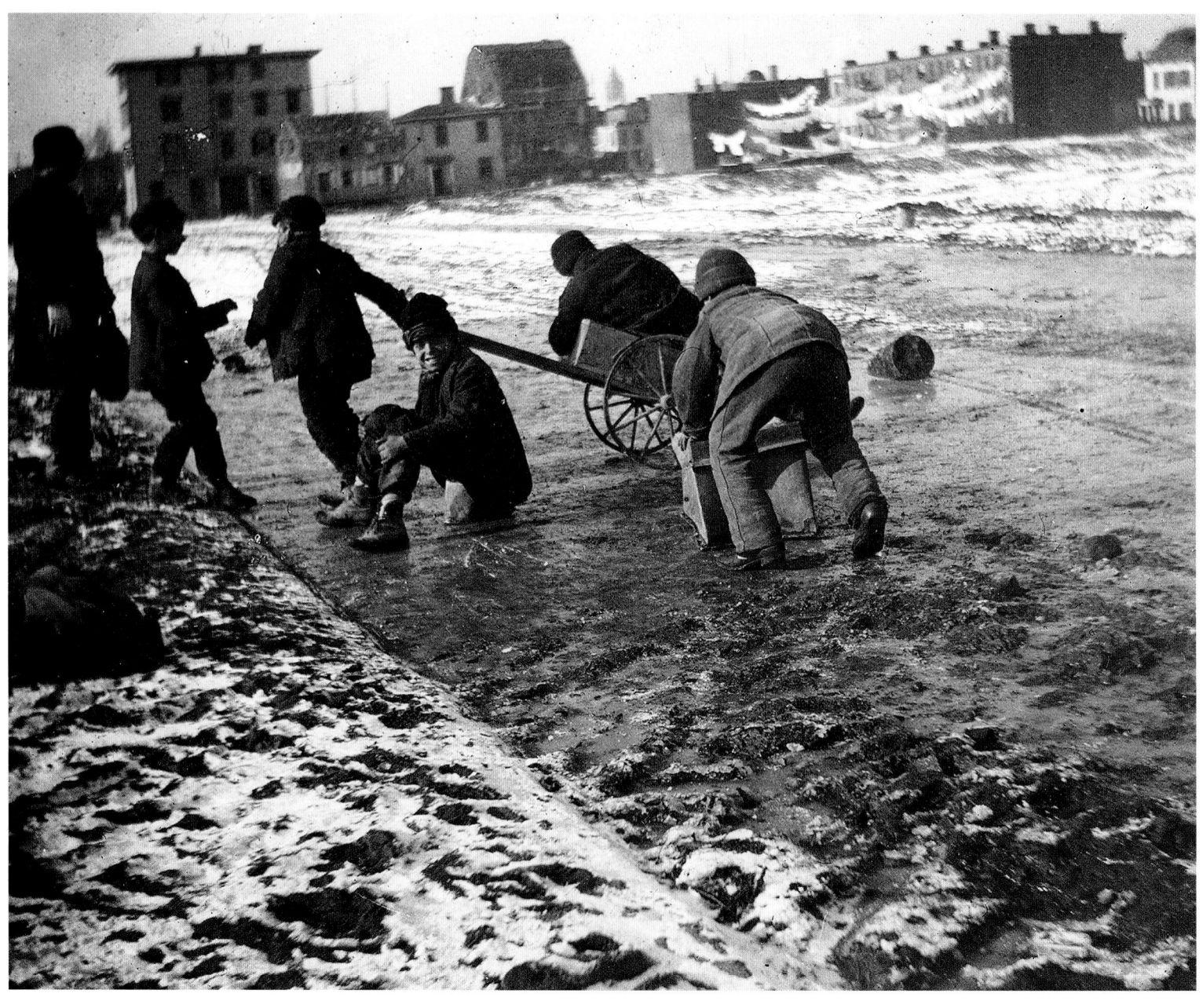

Playing on a road near a vacant lot during winter, two of these boys have cans and one is being pulled in a cart.

This photograph marks an unidentified celebration in the waterfront area of Red Hook that came to be known as the Columbia Street Waterfront District after it was cut off from Red Hook by the Brooklyn-Queens Expressway.

Following Spread: The Hotel Brighton, built along the water's edge, opened in 1878, a terminus for the Brooklyn, Flatbush & Coney Island Railroad. The three-story hotel, renamed Brighton Beach Hotel, soon lost a neighboring hotel to the ocean's waves. By 1888, its own music pavilion was threatened, so the 5,000-ton Brighton Beach Hotel was jacked onto 24 rails and 112 platform cars. Six locomotives then pulled it to safety, 495 feet inland.

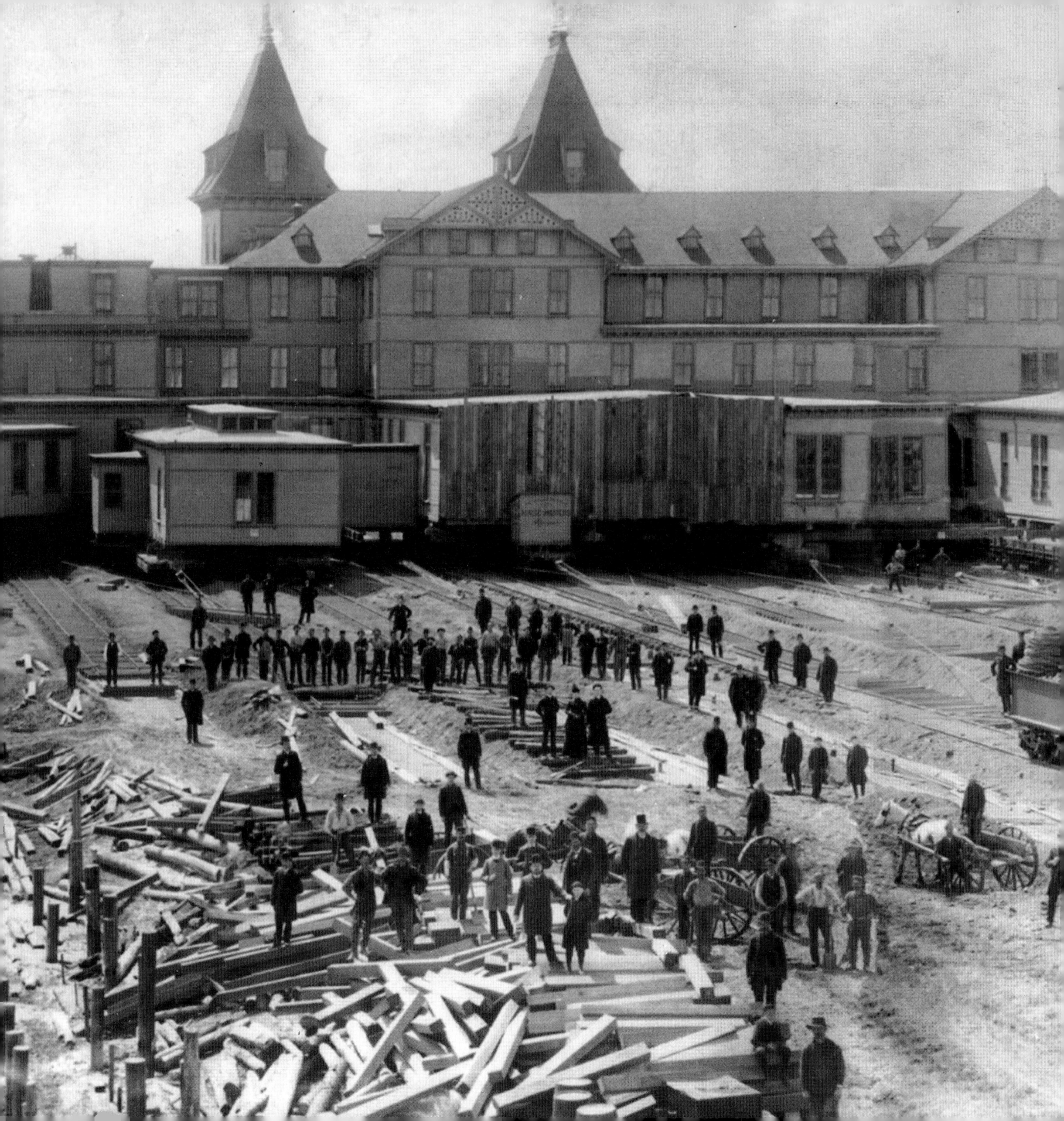

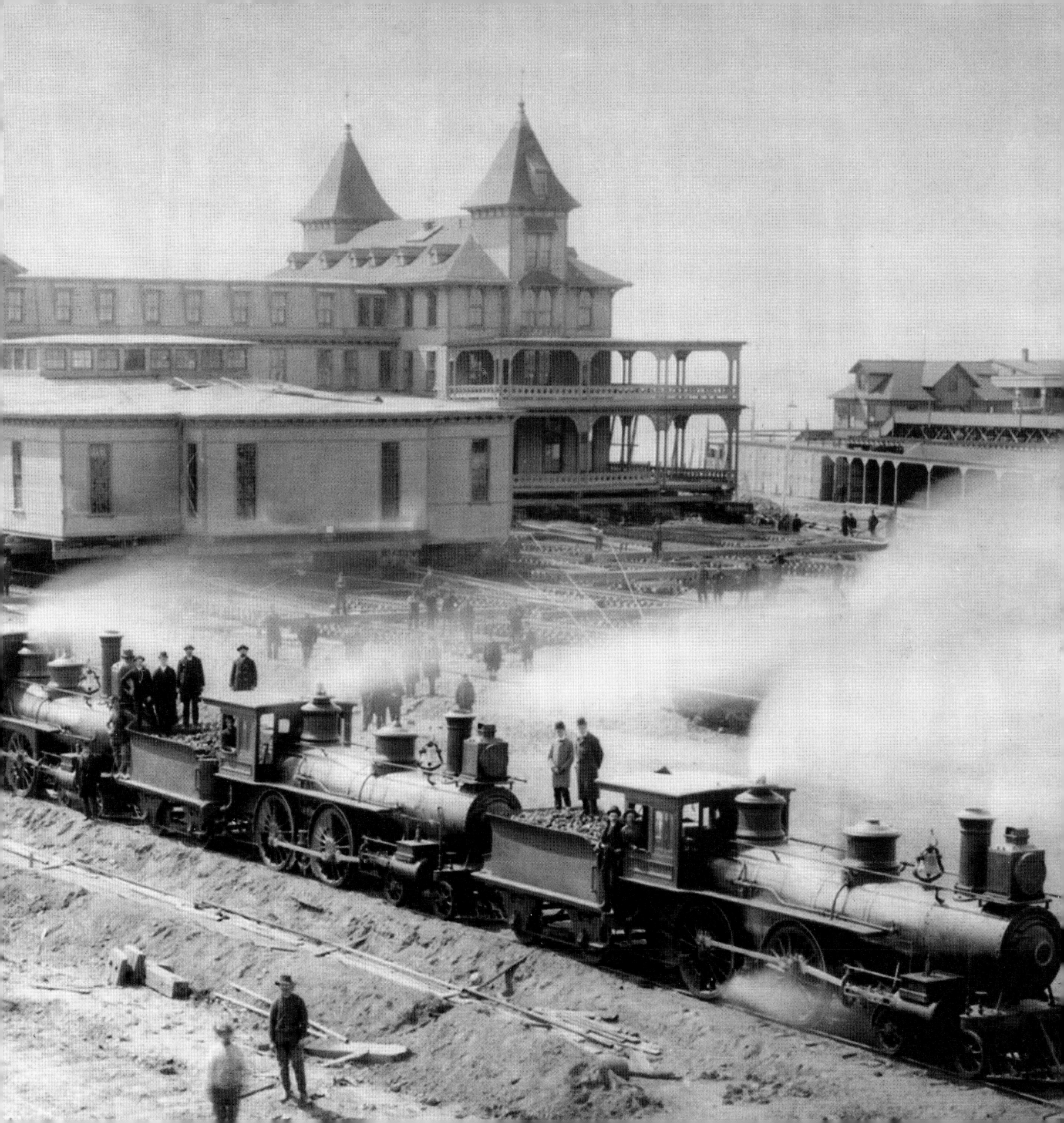

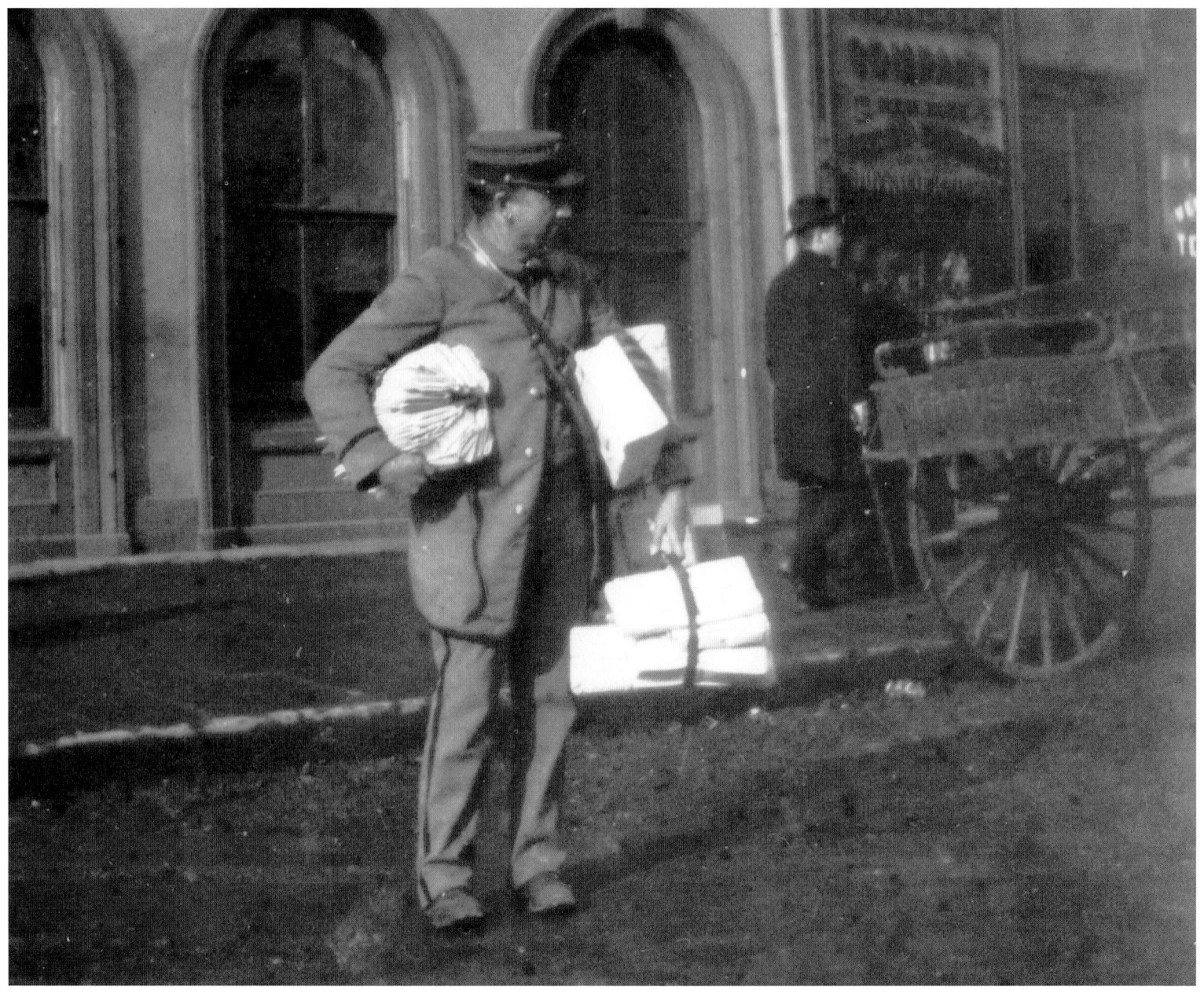
Brooklyn's Post Office was such a busy place in the late nineteenth century that the government had to build a new General Post Office in 1890. The busiest times for a mailman were Christmas and Valentine's Day. Letter carriers made two to three deliveries per day without carts.

Opening in 1880, the Sheepshead Bay Race Track was one of three racetracks in the independent town of Gravesend. Managed by August Belmont, Leonard Jerome, and Pierre Lorillard, it was the most successful of the Brooklyn tracks until it closed in 1910. This picture shows a groom walking a horse in the paddock. When racing was not scheduled, the grounds served as a public park.

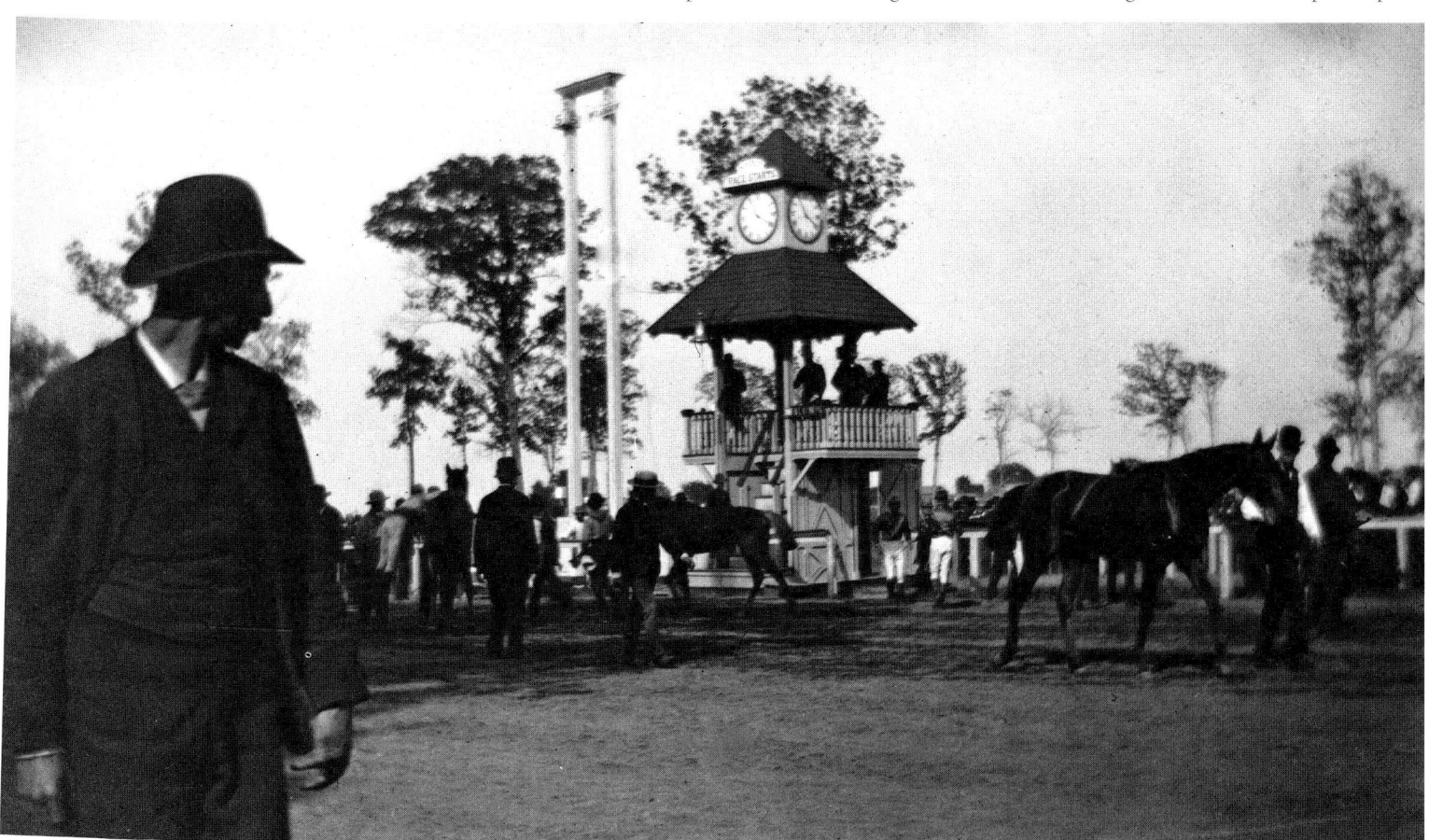

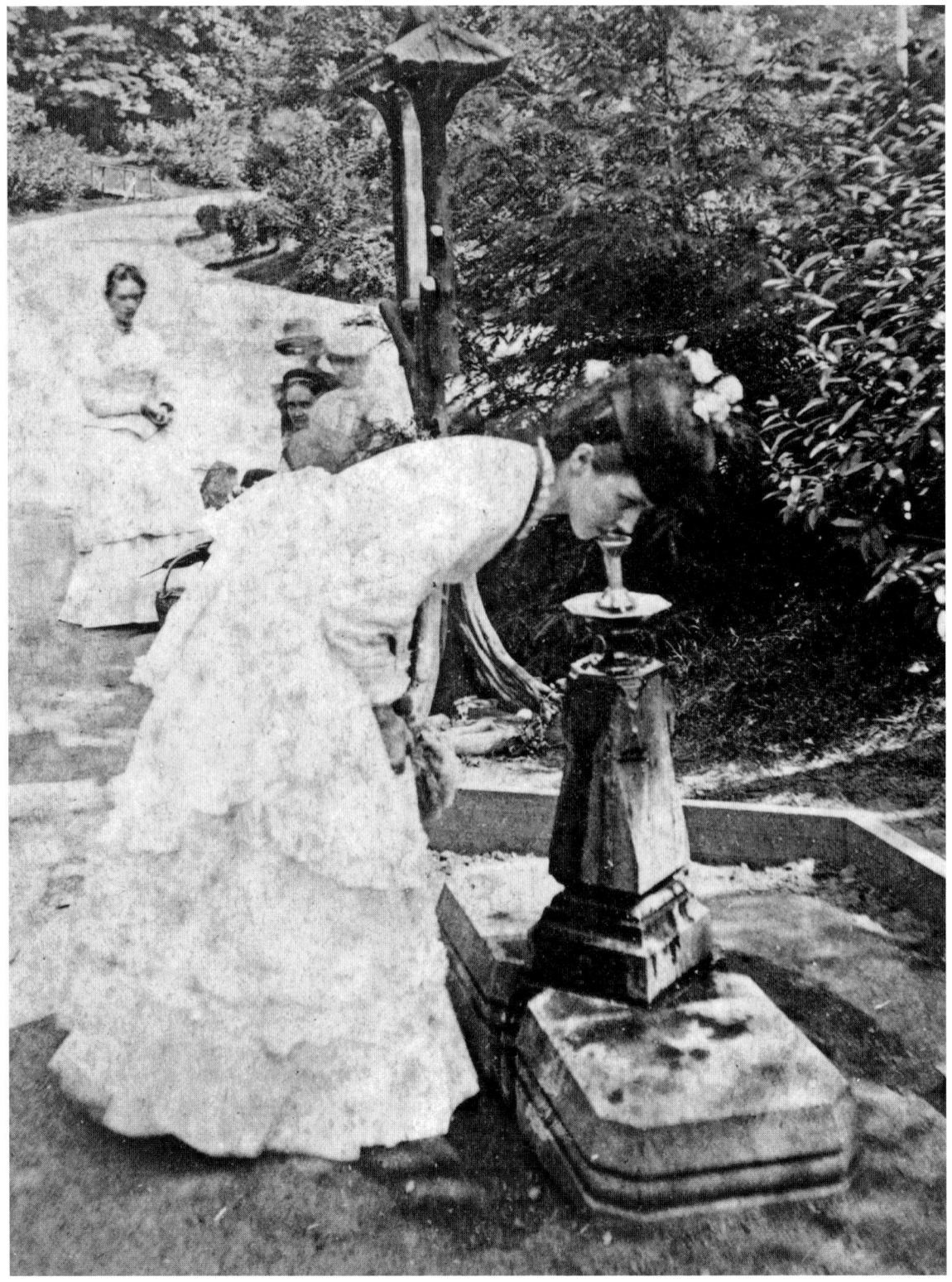

In 1867, Prospect Park opened to the public, incomplete though the park was at the time. Still, it represented a major achievement for designers Frederick Olmsted and Calvert Vaux, who had also designed Manhattan's Central Park. As Olmsted himself noted, many in the press described the Brooklyn park as "in some respects more attractive than the Central Park in New York." An oasis in central Brooklyn, Prospect Park had lakes, a woodland, and fresh drinking water.

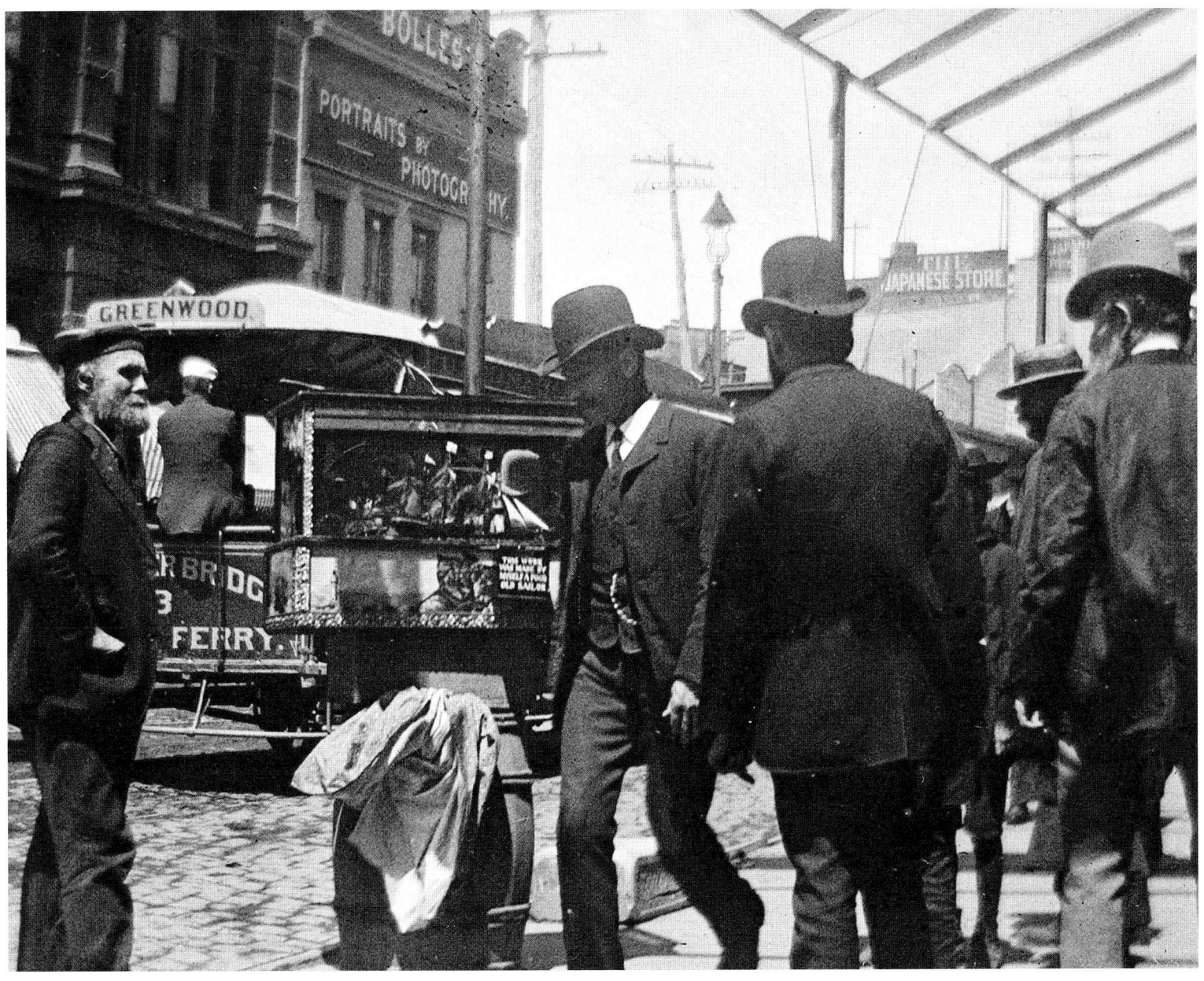

At this unidentified Brooklyn location (possibly South Brooklyn, since the trolley indicates a ferry line going to Green-Wood Cemetery), several businessmen gaze at a ship model on top of a barrel next to an elderly sailor. Brooklyn's maritime history includes several centuries when shipping served as a primary means of transportation for people and products.

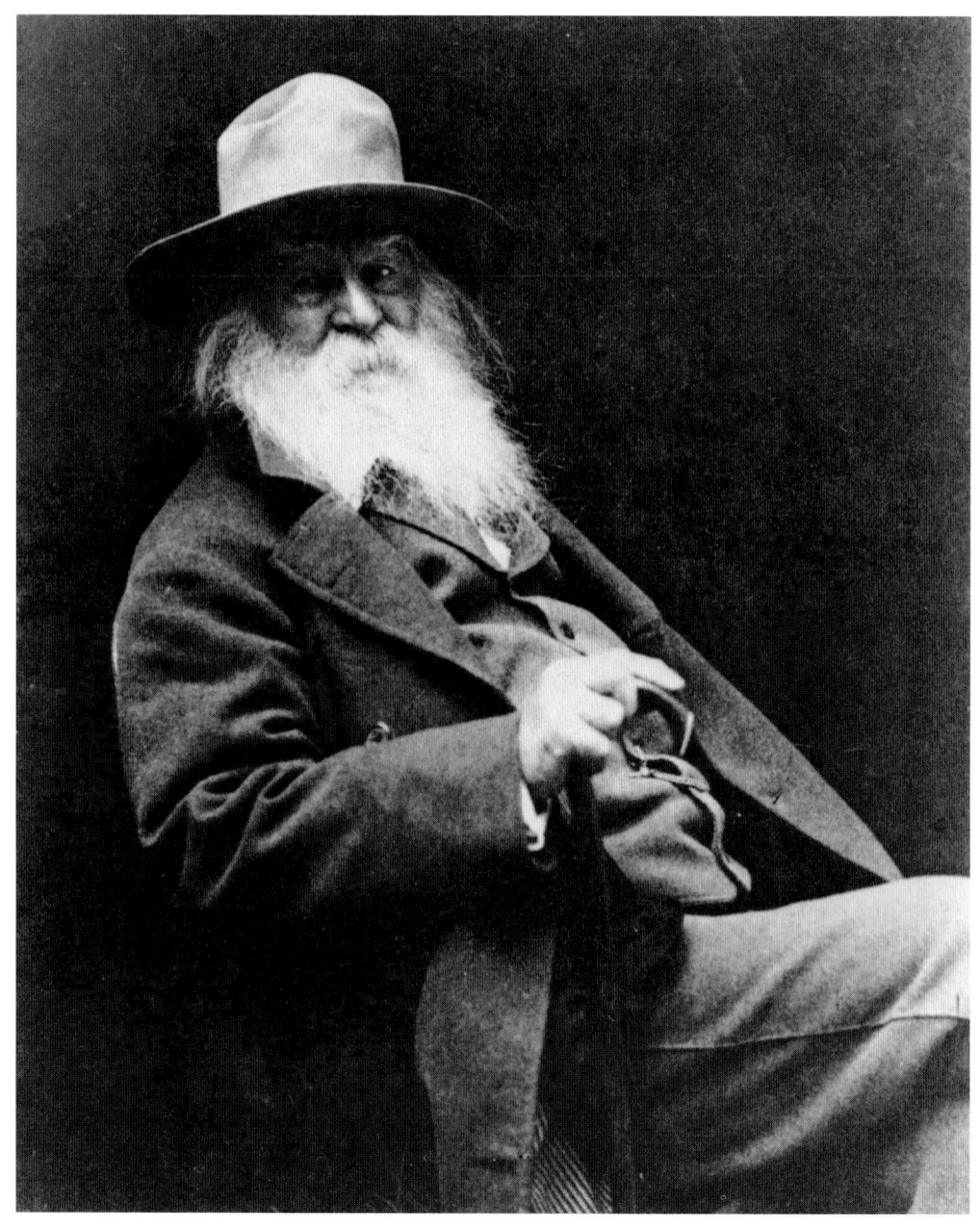
A studio portrait of the venerable poet Walt Whitman, a lifelong Brooklynite, editor of the *Brooklyn Eagle,* promoter of Brooklyn's first official park in Fort Greene, and author of "Crossing Brooklyn Ferry" among his many influential works.

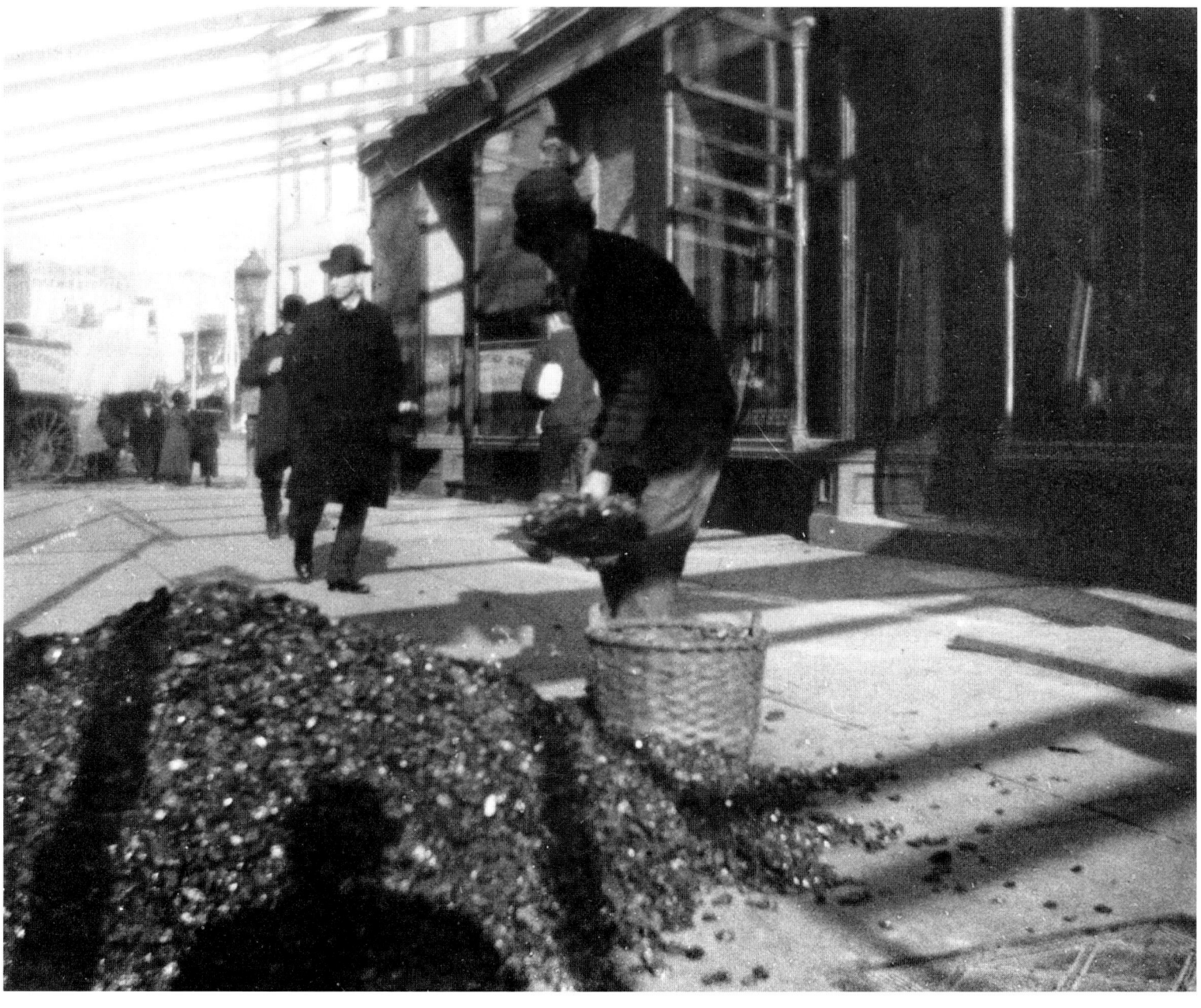
Before the development of alternate fuels, coal was the primary energy source. Coal would be delivered from trucks to a coal chute or to a sidewalk where it would be transferred by baskets to the furnace room. Here, a laborer shovels coal from a Brooklyn sidewalk into a basket.

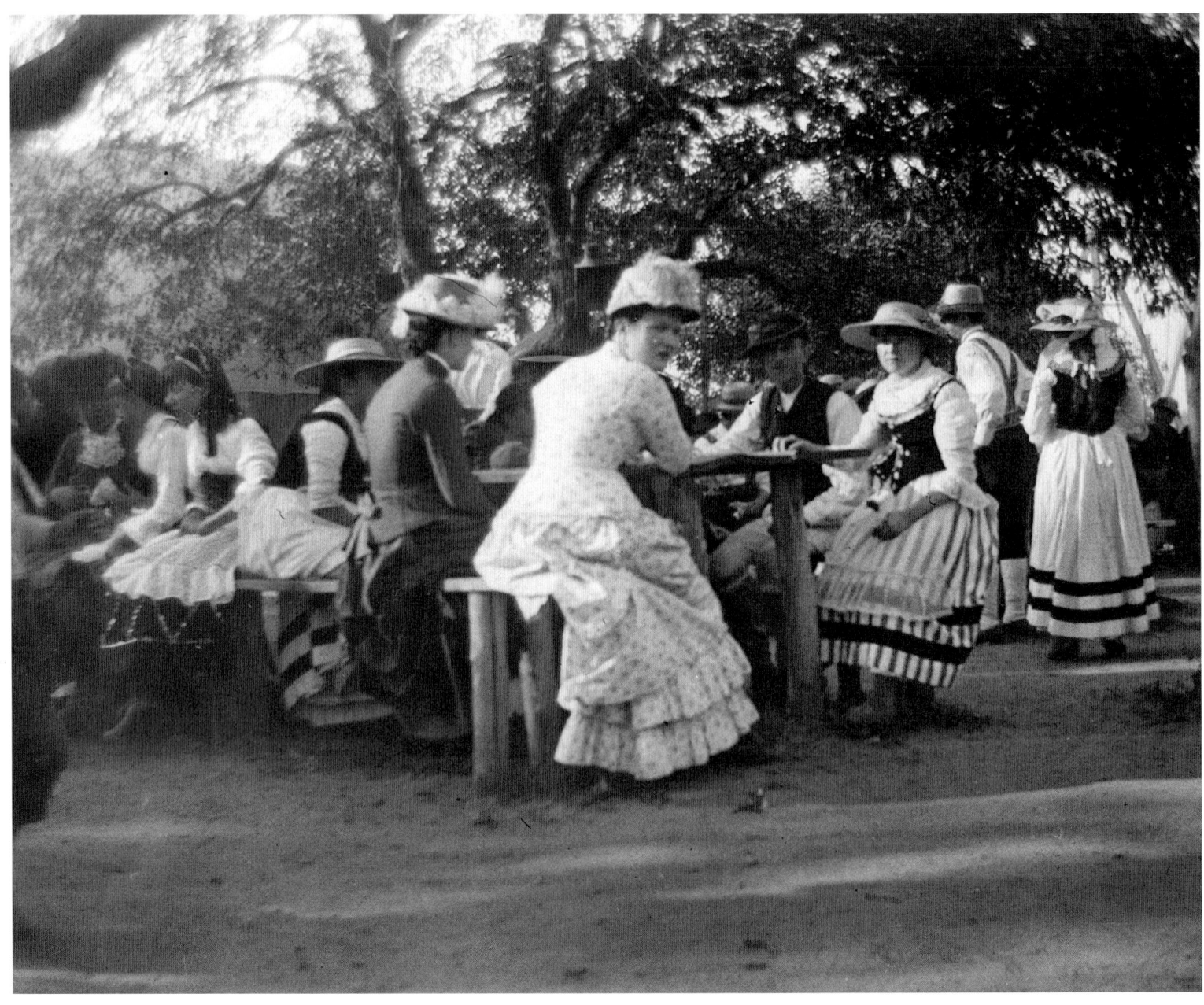

Prospect Park became a boon for Brooklyn, offering a sylvan respite from crowded neighborhoods. Individuals and organizations retreated here, often in festive dress. The Swabian Society, a German social organization, enjoys a picnic—a Victorian invention—among the park's trees. The Germans immigrated in large numbers from the 1840s forward and settled in northern Brooklyn in the communities of Williamsburg, Greenpoint, and Bushwick.

Most photographs of Coney Island show white families crowding the beach—never African Americans or Asians, who usually would be found working at concessions or out of the public view. But in this nineteenth-century image, an African American family in their Sunday clothes—people dressed for the beach and the parks back then—enjoy the sea and sand in front of the Iron Pier.

This photograph, taken about 1885, shows a section of Columbia Heights with its brownstone houses and the Brooklyn tower of the Brooklyn Bridge in the background. On the sidewalk, a man is walking away from the Brooklyn ferry, which ran until the middle of the twentieth century.

In winter, Brooklynites impatiently awaited the appearance of a red circle on flags over Prospect Park's entrance and on trolley cars throughout the city. This circle signaled that the ice on the lake was four inches thick—solid enough to allow skating. Ice skating, along with bicycling, became a popular craze after the Civil War. The skating chair was for ladies whose ankles couldn't support them, or for chivalrous men.

In 1814, Robert Fulton launched his steam-propelled ferry, the *Nassau*, sparking development of Brooklyn. Two years later, Brooklyn was incorporated as a village; by 1820, a local merchant, Hezekiah Pierrepont, had gridded 60 acres of his own land for development. This photograph of the ferryboat *Fulton* is from a copy inscribed to Walt Whitman. An earlier *Fulton* was built by Robert Fulton at the Navy Yard in 1815.

Seen here, the battleship USS *Maine* launched from the New York Naval Station in Brooklyn in 1889 and was commissioned in 1895. The 1801 purchase of land from John Jackson for what would commonly be known as the "Brooklyn Navy Yard" tied the city of Brooklyn to a long naval tradition connected with government. The shipyard outfitted the *Monitor* for the Civil War.

Green-Wood Cemetery opened its gates in 1840 as the first rural cemetery in Brooklyn. Here, an individual by the name of T. L. Johnson is being buried at Green-Wood.

As the United States prepared for the Spanish-American War, the Navy Yard armed itself with this machine gun and the battleships in the background. Machine guns were first used in the Civil War with introduction of the Gatling gun. In 1881, the Maxim gun replaced the Gatling.

At the Brooklyn Navy Yard Hospital, a doctor and aides pose with a patient. The 1838 hospital is a marble structure with eight square stone piers at its main facade. With the Surgeon's House and the Morgue (1863), the hospital buildings were abandoned when the Yard closed in the 1960s. Today, Steiner Studios is seeking to acquire the property for movie-making purposes.

Thomas De Witt Talmage, a dynamic Presbyterian minister, moved to Brooklyn's Central Presbyterian Church in 1869 and built his first tabernacle. In a series of conflagrations, each succeeded by construction of a larger structure, his tabernacles burned in 1872, 1889, and, the one in this picture, 1894. The following year, Talmage moved to Washington, D.C.

Children and adults wade in the Coney Island waters near the Iron Pier. Since many people did not know how to swim, safety ropes were strung into the ocean to where a lifeguard would sit in a rowboat to prevent bathers from going further.

This idyllic photograph of a young woman wearing a long dress and a hat and wading in the surf at sundown contradicts the history of Norton's Point, once the most crime-ridden of Coney Island's beaches. In the 1890s, this west end of Coney Island became Sea Gate, a gated community for the wealthy.

Boys' High School, opening as Central Grammar School in 1878, divided in 1886 when the girls' division moved to a new building. Boys' High School moved to this Romanesque Revival structure in 1892. In 1976, Boys' High School began admitting girls and was renamed Boys' and Girls' High School. The building above was designated a historic landmark in 1973. Alumni of Boys' High School include composer Aaron Copland and authors Norman Mailer and Isaac Asimov.

This 1896 photograph shows the county penitentiary, part of the complex of county buildings. Built in 1848 to resemble a fortress, it was also known as Crow Hill Penitentiary. After its demolition in 1902, the neighborhood that grew there became Crown Heights, where the Brooklyn Dodgers moved in 1913. In 1972, Medgar Evers College, a unit of the City University of New York, opened on the site of the prison.

In the Victorian Age, circuses traveled to their audiences. Wherever an empty lot appeared near a railroad, a circus would call the spot home. This P. T. Barnum tent is set up in the Bedford-Stuyvesant neighborhood at Broadway and Halsey Street. The bicycles shown here are representative of the fad for bicycling in Brooklyn, often called a "wheelman's paradise."

A statue of a youthful Ulysses S. Grant, Union general and president of the United States, stands outside the former Union Club in the Crown Heights area. Installed and dedicated the year before the completion of Grant's Tomb in Manhattan, it occupies Grant Square at the intersection of Dean Street and Bedford Avenue.

In this view of the Brooklyn Bridge, note the multiple transportation modes represented crossing the span: train, trolley, wagon, and pedestrian. Trains started crossing the bridge in September 1883 and ran until 1944. Trolley cars crossed the bridge until 1950, when service stopped after 52 years.

Nicknamed the "Intelligent Whale," this 1864 hand-powered submarine stood inside the Sands Street gate of the Navy Yard. The 28-foot-long vessel, also called "Halstead's Folly" after its owner, General Nathaniel Halstead, held from 6 to 13 persons. Condemned by the Navy in 1872, it was offered for sale in 1897 and finally sent to a museum in Sea Girt, New Jersey, in 1999 after the Navy Yard had closed.

This flower-draped ship at the Brooklyn Navy Yard memorialized the victims of the USS *Maine*. Built at the Navy Yard, the *Maine* blew up in the harbor of Havana, Cuba, setting off the Spanish-American War in 1898. The distinctive tower of the ship is memorialized in Arlington National Cemetery.

Strolling across the Brooklyn Bridge has been an experience from the time it opened in 1883, when the toll was a penny to walk across. By the time these pedestrians made their way, in 1899, the bridge connected two of the boroughs of Greater New York, rather than two separate cities, for the consolidation of 1898 had made them one.

A New Age

(1900–1929)

At the dawn of a new century, everything old was new again. New borough. New borough president. New bridges. New subways. New baseball team. New discoveries.

To begin with, it was easier to go to Brooklyn, and there was more reason to do so. Trolleys and subways crisscrossed the borough. A new Long Island Rail Road terminal accessed eastern Long Island. Automobiles puttered along the streets competing with bicycles. An occasional airplane could be seen in the sky. And two new bridges connected Brooklyn to Manhattan, encouraging new immigrants to cross over the river and provide Brooklyn with manpower.

New hotels welcomed businessmen and other visitors. Throngs crowded the Fulton Street department stores. Scholars searched through the files of the Long Island Historical Society and attended performances at the Brooklyn Academy of Music. The new Brooklyn Museum opened near Grand Army Plaza, the creation of a new Brooklyn Public Library was signed into law, and a Children's Museum debuted. Out in Midwood, Vitagraph created new moving pictures for the new movie theaters. Athletes ran the Brooklyn Marathon or volleyed tennis balls. After 1913, a new Ebbets Field beckoned, and the crowds followed the dream of victory.

And there was Coney Island. The opening there of Steeplechase had created an "amusement park," to be followed by two others, Luna Park and Dreamland. Crowds milled in the streets and alleys and the Bowery. Millions of lights, exciting rides, wonderful food, and, then, a boardwalk. For a while, fans could watch motorcar racing at Sheepshead Bay or Brighton Beach. Then, in 1911, Dreamland burned to the ground.

World War I interrupted the revelry and development but not for long. In Sunset Park, the Military Transport Base was established, later to become the Brooklyn Army Terminal. Veterans returned—to Prohibition and women's suffrage. Reality contrasted the artifice of Coney's spectacle, but the beach was real. New schools beckoned: Girls' High, Erasmus, Pratt, even a new Brooklyn College. Business was brisk along the waterfront at Bush Terminal and Greenpoint and the Erie Basin.

A growing middle class received better social services and health care at new hospitals. Margaret Sanger established her first birth control clinic in Brownsville, in 1916, and was thrown in jail. Crime surfaced. And just around the corner, the Depression.

This turn-of-the-century photograph shows the 5th Avenue elevated where it meets Flatbush Avenue, several blocks from the Long Island Rail Road terminal. A delivery wagon for Brooklyn Teas stands by the curb. Among the roof billboards are one for Martin's Department Store on Fulton Street, Ward's Baths and Sea Gate in Coney Island, and the Hippodrome, the New York performance arena.

The St. George Hotel, starting small in 1885 but by 1930 comprising eight buildings, became the largest hotel in New York City. Occupying a full city block in Brooklyn Heights, the St. George included a grand ballroom, an indoor saltwater swimming pool, a subway station inside the hotel, and rooftop dining and dancing. Seen here early in the twentieth century, the St. George enjoyed its most successful years during and after World War II. Part of the hotel is now a college dormitory, and other buildings are condominiums.

Prospect Park designers Frederick Law Olmsted and Calvert Vaux completed their Brooklyn project in 1873, though additional elements continued to be added. The Soldiers and Sailors Memorial Arch seen at left in this early 1900s view to the east is dedicated to Union forces in the Civil War. Extending ahead is Eastern Parkway, with the Brooklyn Museum in the distance. The columns at right, designed by Stanford White and added in the 1890s, border the entrance to the park. The park, the parkways, and the arch are historic landmarks.

Henry Ward Beecher, a prominent abolitionist and preacher at Brooklyn's Plymouth Church of the Pilgrims from 1847 to 1887, is remembered with this 1891 statue, seen here shortly after the turn of the century. Originally located in front of Brooklyn Borough Hall, it now stands at the Johnson Street end of Cadman Plaza.

Completed in downtown Brooklyn in 1891, this Romanesque Revival post office building had pneumatic tubes installed in 1897 to speed mail across the Brooklyn Bridge and between other New York City locations. The tube system covered 27 miles, but the tubes were discontinued in Brooklyn in 1950.

These snow and ice–encrusted trees in 1904 present a winter wonderland in Prospect Park, another scenic advantage of urban woodlands.

Seen here, presumably on Prospect Park Lake, are four members of the Saratoga Skating Club: E. Crabb, Phil Kearney, H. Earl, and W. Sutphen. Ice skating achieved popularity in the mid nineteenth century with clubs, carnivals, and contests. Prospect Park's Boat House became a Skate House, and 10,000 fans followed skating activities. After a decline toward the end of the century, the sport revived.

The new East River bridge that opened in 1903 was the all-steel Williamsburg Bridge, which changed Williamsburg from a fashionable resort to an immigrant district filled with overflow from Manhattan's Lower East Side. Here showing the middle suspension section still incomplete, the bridge today carries two sets of subway tracks and four lanes of traffic.

Dreamland, one of the three major amusement parks in early Coney Island, was created in 1904 by William Reynolds, who was inspired by the Chicago Columbian Exposition of 1893. In this Dreamland view, the Shoot-the-Chutes ride is headed toward the lagoon, with a copy of Spain's Tower of Seville at the opposite end. Dreamland burned in 1911.

The Brooklyn Institute of Art and Sciences, now known as the Brooklyn Museum, opened in 1897 and was the first tenant of Institute Park. Stanford White designed it to be the largest museum in the world, but only one-quarter of his original design was realized. The facade under construction here about 1904 would be completed in 1906, with a broad exterior stairway extending the width of the columns. The stairway was removed in 1933 and a modern entrance added in 2004.

Noted for its Egyptian and African collections, its Americana, and a garden containing Brooklyn artifacts, the Brooklyn Museum maintains an eclectic collection in an ever-expanding institution for the more than 500,000 patrons who visit annually.

Later demolished, this Bergen Homestead built in 1662 housed the family of Norwegian settler Hans Hansen Bergen, whose relatives married into the Dutch Rapalye family.

Shamrock III, owned by Sir Thomas Lipton, undergoes maintenance at Erie Basin prior to a challenge race against *Reliance* in the America's Cup in 1903. Erie Basin contained many ship-repair dry docks until the 1980s. *Shamrock II* lost in three out of three races, getting lost in the fog in the third one. Lipton put it up for sale.

Officially the New York Naval Shipyard, the Brooklyn Navy Yard, seen here in 1904 at the Sands Street entrance, grew in importance from its early years as an outfitter of wooden ships to become the largest naval construction facility in the United States. Sands Street in Vinegar Hill became renowned for its bawdy nightlife catering to sailors on leave.

Designed by Leffert Buck, the Williamsburg Bridge, Brooklyn's second bridge to Manhattan, opened in December 1903 with a fireworks display meant to emulate that of the Brooklyn Bridge's opening ceremony. In spite of its longer length, only the middle section of the Williamsburg Bridge is suspended. This view is from Manhattan toward Brooklyn.

This 1892 tribute to Union forces who died in the Civil War was created by John Duncan, architect of Grant's Tomb, and inspired by the *Arc de Triomphe* in Paris. Originally named Prospect Park Plaza, the location of the arch was renamed Grand Army Plaza in 1926. The top of this 80-foot landmark is adorned with a four-horse chariot and sculptures dedicated to the Army and the Navy, both created around the turn of the century by Brooklyn sculptor Frederick MacMonnies.

The Brooklyn Bridge had been open roughly 20 years when these pedestrians and elevated trains crossed it.

Tugboats, essential aids to shipping, maneuver in the East River in 1905 with the Brooklyn Bridge and the Williamsburg Bridge crossing the river in the distance.

Battleships and cruisers are docked in the Brooklyn Navy Yard, with the cruiser *West Virginia* in the foreground. At the end of the nineteenth century, the larger battleships were constructed when production increased after the Spanish-American War. Other ships in this 1907 picture include the battleship *Indiana*, the cruiser *Pennsylvania*, the cruiser *Colorado*, the battleship *Alabama*, and the cruiser *Maryland*.

At Coney Island in 1906, a tribe of Igarotes from the Philippines are presented in native dress in a "natural habitat." The sideshow practice had started with world's fairs where non-whites—Africans, Eskimos, American Indians—were exhibited with "freaks" as natural curiosities.

Erroneously described as "City Hall," this capitol of Brooklyn became Borough Hall in 1898. The elevated railroad, developed in Manhattan in 1867, became popular in urban areas, with Brooklyn's first elevated arriving a decade later in Brighton Beach. In this 1907 picture, the Fulton Street elevated curves past Borough Hall toward the Brooklyn Bridge. The first subway from Manhattan's Park Place to Brooklyn's Borough Hall was under construction and would open in 1908.

President Abraham Lincoln, who visited New York twice and Brooklyn once, is remembered by this 1869 statue that stands in Prospect Park's flower garden near Wollman's ice skating rink. In a 1903 mishap, three years before this photo was taken, the statue was blown from its pedestal during a lightning storm.

Theaters thrived in Brooklyn, with many lined along Flatbush Avenue between Fulton Street and Prospect Park. The New Montauk Theater, at Livingston Street and Hanover Place, replaced the old Montauk Theater in 1905. The original theater, opened in 1895 near the entrance to the Manhattan Bridge, was to be demolished to create Flatbush Avenue Extension but instead was moved and renamed Imperial Theater.

Commissioned in 1838, Green-Wood Cemetery provided a "Greensward" for park planners Olmsted and Vaux. The spectacular, 1865 Gothic Revival gate and gatehouse was created from New Jersey brownstone and features four panels depicting Death and Resurrection carved by John Moffit. Within the cemetery's 478 acres are half a million graves, and memorials for many of America's more notable figures.

Established in Clinton Hill in 1887 and run by founder Charles Pratt, owner of the Astral Oil Works in Greenpoint, Pratt Institute accepted men and women of all races. The Engine Room of this art and industrial school remains a working example of Victorian engineering.

Pratt Institute's Free Library, a historic landmark designed by William Tubby, became Brooklyn's first library in 1896 and offered a degree in library science. Here, some years after it opened, young readers make use of the Children's Reading Room.

On Johnson Street in downtown Brooklyn, the *Brooklyn Daily Eagle* newspaper building and the Brooklyn Central Post Office stood as neighbors. The *Brooklyn Eagle,* founded in 1841, became America's most widely read afternoon newspaper in the 1860s. The *Eagle* closed in 1960 after a lengthy labor dispute; the post office has been reduced to a local station, with major distribution relocated.

Developing from Brooklyn's first railroad in 1832, the Long Island Rail Road was established two years later and remains the nation's only railroad operating under its original name. The Atlantic Avenue terminal building in this picture opened in 1907 to facilitate transportation between Manhattan and Brooklyn's Gold Coast in Park Slope. Today's future plans include changing Atlantic Avenue from a terminal to a station and expanding service to Grand Central Terminal.

Policemen received congratulations from presidential candidate William Jennings Bryan, at center, and Brooklyn Borough President Bird Coler at a Borough Hall ceremony, February 5, 1908.

Republicans of Brooklyn held forth in their Union League Club in the town of Bedford. This 1890 brownstone advertised its party affiliation with sculptures of Lincoln, Grant, and the American eagle. Initially, it was founded to support the Union cause in the Civil War. Seen here about 1906, the building today is a senior citizen facility.

This May 24, 1908, photograph of James Simcox, a mascot of Spanish-American War veterans, was probably from a Decoration Day memorial. Brooklyn is closely associated with this war since the battleship *Maine* was built in the Brooklyn Navy Yard and Admiral Winfield Schley, commander of the fleet, sailed on the flagship cruiser *Brooklyn*.

Luna Park, a 50-acre amusement park created by Frederic Thompson and Elmer Dundy, opened to sellout crowds in 1903. Illuminated by a million electric lights, it averaged daily attendance of 90,000. Designed to resemble ancient Baghdad, it featured a domed theater, spires, revolving lights, and the Kaleidoscope Tower. In 1944, the park was destroyed by fire.

Girls' High School was originally part of Central Grammar School, founded in 1878 and the oldest high school in New York City that began as a public school. The girls' division moved in 1886 to Nostrand Avenue, and in 1891 the boys' and girls' divisions formally became separate institutions. Seen here early in the twentieth century, Girls' High School closed in 1964, merging into Boys' and Girls' High School in 1976. Girls' High School alumnae include Representative Shirley Chisholm (D-NY) and actress-singer Lena Horne.

A police traffic squad attends an open-air Mass at the Brooklyn Navy Yard in May 1908. The creation of a police traffic squad was one of the twentieth-century organizational developments intended to improve police professionalism. Prior to this new effort, Commissioner Theodore Roosevelt had introduced a bicycle squad. With the advent of the automobile, a traffic squad was established in 1908.

In the days before electronic communication, news was distributed by newspapers with extra editions. Newspapers were sold on the streets by armies of newsboys, or "newsies," usually orphans or abandoned children. Eventually, they organized and even struck against the *Evening World* and the *New York Journal.* The arrival of newsstands and home delivery phased them out. Photographed by Lewis Hine in 1910, this newsie is selling papers at the Brooklyn Bridge.

With the opening of the Borough Hall station, Brooklyn had a direct subway connection running south under the East River from City Hall in Manhattan. The Interborough Rapid Transit (IRT) and the Brooklyn-Manhattan Transit (BRT) expanded and by 1913 had added 123 miles of subway routes. In this picture, a trolley passes in front of Borough Hall on Joralemon Street about 1908, the year the station opened.

In 1909, women were limited to certain trades, usually related to domestic work. Here, they sew flags at the Brooklyn Navy Yard for use on naval vessels.

The "Brooklyn Park" seen here in 1908 was not Ebbets Field but Washington Park. The Brooklyn Superbas—the future Brooklyn Dodgers—had moved from Eastern Park back to Washington Park, and the fans and ice cream vendors waited anxiously for the first ball game.

An open-air Mass is held at the Brooklyn Navy Yard in 1908.

The concept of the urban department store originated in Brooklyn. Abraham & Straus, at right in this 1909 picture, was founded in 1865 as Wechsler & Abraham. In 1883, the store moved to Fulton Street, and by 1889 it became the largest dry-goods store in New York State. Others followed: Loeser's, Namm's, Martin's. Abraham & Straus became its new name in 1893, and, in 1995, it was renamed yet again as Macy's.

While the New York Marathon started in 1970, Brooklyn held an annual marathon starting in 1908. The 150 runners started at the Thirteenth Armory in Crown Heights, ran along Ocean Parkway, then past Coney Island's amusement parks to Sea Gate and return. Braving 30-degree temperatures on Lincoln Day, more than 250,000 spectators watched the 1909 event seen here.

James Crowley, at center, the favorite in the Brooklyn Marathon, finished second to James Clark in the 26-mile race on February 12, 1909, while a quarter of a million Brooklynites watched. The Brooklyn Marathon continued until 1915, when temperatures dropped to zero.

Religious Jews pray over the East River from the Williamsburg Bridge on the high holiday Rosh Hashanah, the Jewish new year's day, 1909.

Dr. Frederick Cook, an explorer and physician who traveled with Admiral Robert Peary to the Arctic in 1891, returned to the Arctic in 1908 in an attempt to be the first to reach the North Pole. On Cook's return, Peary disputed Cook's claim of having succeeded in his quest, igniting a controversy that has yet to be resolved. Cook's 100,000 followers in the Dr. Frederick A. Cook Society supported him with "We believe in you" on the top of this arch that appeared near his Bushwick Avenue mansion in 1911.

This photograph of a Scottish bagpiper on a Coney Island backstreet points up the incongruities of the amusement center. Signs advertise palmistry and crullers. The top of the Iron Tower in the distance indicates the photo was taken before May 1911, when the tower was destroyed in the Dreamland fire.

When the Brighton Beach Race Track closed in 1908, owners converted it from a horse racing venue to a motordrome for racing cars and motorcycles. In the distance is the nascent development of Manhattan Beach, although both the Manhattan Beach and Oriental hotels can already be seen in this 1912 photograph.

With little income, this Brooklyn family is making brushes for sale. The five-year-old on the right joins her brother and a neighbor in this home business photographed by Lewis Hine.

A supervisor helps a blind man make toys in a Brooklyn factory in 1915.

Charlie Ebbets moved his Brooklyn Dodgers into this new Crown Heights ballpark, Ebbets Field, in 1913. Seen here, the first game played at Ebbets Field was an exhibition game on April 5, 1913, between the Dodgers and the New York Yankees. The pitcher on the mound is Ray Caldwell of the Yankees.

95

Located on Sullivan Street, Ebbets Field, seen here in the 1920s, was the third home to the Brooklyn Dodgers, after Washington Park and Eastern Park. Named for owner Charles Ebbets, it became the site of eight World Series. The Dodgers won the World Series at Ebbets in 1955, but Dodgers executive Walter O'Malley moved the team to Los Angeles in 1957. Ebbets Field was demolished and replaced with Ebbets Field Apartments.

Starting as an outfielder for the Dodgers in 1912, Casey Stengel played in Ebbets Field for five years. After playing for other teams, he returned to Brooklyn as a coach in 1932 and as a manager in 1934. He was elected to the Baseball Hall of Fame in 1966.

In this photograph taken in 1915 after Theodore Roosevelt left the presidency, he is back in Brooklyn, where his wife and daughter are buried. As a civil service administrator for the federal government and former police commissioner of New York City, he had a strong interest in Brooklyn's affairs and is seen here inspecting a city workshop in the borough.

This busy intersection of Atlantic, Flatbush, and Fourth avenues shows the Long Island Rail Road terminal behind the elevated train. The small stone building was the entrance to the subway below. The building still exists as a historic landmark but no longer leads to the subway.

Located in the Ridgewood section of Brooklyn, this small hospital, Bethany Deaconess, was founded in 1901 through the efforts of a German Methodist Episcopal movement started in 1893. With a deaconess as director, the hospital also served as a home for the elderly.

This Coney Island thoroughfare shows an overloaded tourist bus and a trolley car in the heart of Surf Avenue in April 1917. The Cadillac Restaurant at right offers a "shore dinner"—a sampling of seafood popularized by "Diamond Jim" Brady, who visited Sheepshead Bay and Manhattan Beach in the nineteenth century.

In 1914, the United States invaded and occupied the Mexican port of Veracruz as a result of unrest caused by the Mexican Revolution. During the attack by the Navy and the subsequent invasion, 17 sailors and marines died. A memorial service for the fallen was held at the Brooklyn Navy Yard, with President Woodrow Wilson, seen here, attending.

A street scene in New Utrecht taken in 1919 at New Utrecht and 14th avenues shows the elevated New Utrecht train trestle, trolley car tracks, and a private car parked.

Documentary emphasis on the living conditions of the poor became prevalent with the social-reform photography of Jacob Riis and others who followed. Here in 1919, a photograph by Edward Rutter, the city photographer for Brooklyn, shows a backyard at 47 Boerum Street in Williamsburg, once a posh neighborhood for the wealthy. With trash, debris, and laundry on the line, the living standards obviously have changed.

These brownstones at 107 Prospect Park West, commonly called "Brooklyn's Gold Coast" because of the wealthy families that lived in the neighborhood, and other single-family homes like them appeared after the Civil War. They were easily accessible by mass transportation from Manhattan. Note the trolley tracks in this 1919 view.

Built in 1890 by Irving T. Bush and nicknamed "Bush's Folly," Bush Terminal, where these men are working, developed into a 200-acre complex of piers, warehouses, and factory lofts. By 1902, the facility had expanded into a major transportation hub.

With expansion in 1902, Bush Terminal created its own rail system to handle the 50,000 railroad freight cars shunted through the terminal yards.

107

With a sailing ship in the distance, this 1918 photograph shows construction material on Greenpoint's DuPont Street Pier, which fronts on Newtown Creek. Shipbuilding moved into Greenpoint after 1840 and peaked with the launching of the *Monitor* in 1862.

Seen here in 1922, Monroe Place between Clark and Pierrepont streets, a one-block street in Brooklyn Heights, remains a street of brownstones. The widest street in Brooklyn Heights, it was named after President James Monroe, who had died in New York.

Dancing the tango al fresco was one of the pleasures of Brighton Beach in the 1920s. Brighton Beach grew as a resort for middle-class Brooklynites. Less rowdy than Coney Island, it was a perfect respite for families.

In this 1920s Coney Island scene, the beach is crowded next to Steeplechase Pier, with boardwalk strollers in the foreground. An excursion boat has just docked at the pier.

Kings County Children's Court, located on the second floor of 102 Court Street above a jeweler, opened in 1903 and is seen here in 1921. Now called Family Court, it is located at 330 Jay Street.

This 1923 view of Atlantic Avenue under the Long Island Rail Road tracks at Alabama Avenue shows the unpaved roadway where cars will be parked.

President Calvin Coolidge poses with the Brooklyn Chamber of Commerce president Raymond Fiero and other chamber members after delivering a speech on prosperity, February 23, 1929.

Brooklyn's Glory Days

(1930–1949)

With the Depression, Brooklyn's old ward system of political control weakened. Ward bosses couldn't prevent breadlines. Still, the "City of Churches" had faith, and the government helped, too. Public housing projects took hold in Williamsburg and Red Hook. The WPA (Works Progress Administration, later Work Projects Administration) painted murals around Borough Hall, at Floyd Bennett Field, at schools.

Brooklyn pharmaceutical companies—Squibb and Pfizer—dominated their field. For health reasons, food moved from pushcarts to indoor markets. Immigrants from Finland introduced cooperatives to Brooklyn's Sunset Park; in Bay Ridge, Norwegians paraded to celebrate Norway's Constitution Day. Immigrants, in their effort to become Americans, attended night classes. And, yes, a tree does grow in Brooklyn.

New York builder Robert Moses promoted parks and parkways. The Belt Parkway encircled Brooklyn for benefit of the many new cars on Brooklyn roads. A new car tunnel to Manhattan was built, although some flew in planes from Floyd Bennett Field—Amelia Earhart, Will Rogers, Howard Hughes, Douglas "Wrong Way" Corrigan.

As the middle class grew, it became the leisure class. Manhattan Beach Baths, Brighton Beach Baths, Stauch's Baths at Coney Island—all were inexpensive escapes. A locker, basketball, dancing. And the notorious Half Moon Hotel, reminding Brooklyn that Murder, Inc., was also a homegrown product. But the first Thursday in June was Brooklyn's day: Anniversary Day, honoring the creation of Brooklyn's Sunday schools, and a school holiday by state law—only in Brooklyn!

With war clouds on the horizon, Brooklyn rolled up its sleeves. Brooklyn Navy Yard, shore artillery, rationing, Rosie the Riveter, air raid drills, shipping out from Brooklyn Army Terminal, victory gardens, Floyd Bennett Field joining the war effort, blackouts, training for the Merchant Marines at Sheepshead Bay. Gold stars. Taps at Fort Hamilton.

With the war over, celebration. Then five million on Coney's sands in 1947, the same year Jackie Robinson signed with the Dodgers. The weather turned crazy: too much snow, too much rain. Luna Park burned twice, 1944 and 1946. The Dodgers lost the World Series—again. Only the dead know Brooklyn. Brooklyn is an enigma.

On the horizon: television, *The Honeymooners* and other Brooklyn characters played for laughs. America guffawed.

After the stock market crashed in 1929, it took several years for the average workingman to feel the effects. But once the Great Depression set in, effects like this bread line at the Brooklyn Bridge anchorage became all too common.

Flanked by Brooklyn Dodgers manager Max Carey and Boston Braves manager Bill McKechnie, Brooklyn Democratic ward boss John McCooey throws out the first baseball to open the 1932 season at Ebbets Field.

Plymouth Church of the Pilgrims, originally named Plymouth Church, at Orange and Hicks streets was completed in 1850. Henry Ward Beecher, a fervent abolitionist, preached here against slavery. The church was known as the "Grand Central Terminal of the Underground Railway." In 1934, the year of this photo, it merged with Church of the Pilgrims and changed its name.

Henry Ward Beecher preached at this stagelike pulpit at Plymouth Church for 40 years. During that time, the congregation grew from 21 to 1,460, with as many as 3,000 attending on Sundays.

This 1932 view shows the Brooklyn waterfront, a cluster of lower Manhattan skyscrapers, and a cruise boat sailing under the Brooklyn Bridge.

This Park Slope photograph from a 1930s *Brooklyn Eagle* file photo shows 7th Avenue at Carroll Street with the Old First Reformed Church in the front-left foreground, along with commercial and residential buildings, trolley tracks, and overhead trolley wires.

This massive Brooklyn Edison headquarters, built in 1923 in the Brooklyn downtown area, was eventually replaced by a new structure built in the 1970s on the site of the Brooklyn Fox Theater. The old Brooklyn Edison Building is now condominiums.

Fire engines respond to a warehouse fire at an unidentified Brooklyn location.

123

Intended as a lookout for fires and crowned with the figure of Justice, the cupola appeared on Brooklyn City Hall as designed by Brooklynite Gamaliel King when it opened in 1849. The cupola and roof burned in 1895 but were replaced by this cast-iron cupola in the Beaux-Arts style three years later. In 1944, the cupola bell was removed to the lobby, with the entire borough hall renovated in 1989.

A roomful of apprentice tailors are seen here training in Brooklyn in the 1930s. Brooklyn's proximity to Manhattan's Garment District allowed overflow production to thrive during this period. The rise of unions and improved transportation encouraged the spread of textile production to other boroughs.

This 1938 fortress of a bank building on Church Avenue, the Green Point Savings Bank, promoted the security provided by a bank in the middle of the Depression after many banks had failed. Green Point was established in 1878.

A subway train moves through the Schermerhorn Street station in 1936. With the spread of subway lines throughout Brooklyn on the beds of former railways, the borough's population grew by half a million in the decade 1920–1930. Subways provided mass transportation for the entire New York City.

Built about 1675 by Dutch settler Jan Martensen Schenck and seen here in Canarsie Park in 1936, this two-room farmhouse was dismantled in the 1960s and transferred to the Brooklyn Museum complete with furnishings and ceramics.

This Brooklyn house reportedly belonged to the Tillary family at 15 Tillary Street. Dr. James Tillary, a noted colonial physician, treated the yellow fever outbreak in 1795 and 1798 and died in 1818. The house was built in 1820 and demolished in 1935, shortly after this photo was taken.

Trolley cars and automobiles run under two elevated rail lines at Fulton Street and Flatbush Avenue in this 1938 street scene.

One of many hotels that dotted Brooklyn Heights and surrounding streets, the 16-story Granada, completed in 1927 at Lafayette Avenue and Ashland Place, was adjacent to the Brooklyn Academy of Music. It featured the Forsythia and Gondola rooms and catered to upper classes. In its later years it became Brooklyn Arms, a welfare hotel, and was demolished in 1994.

Now a New York City landmark, this 1828 New Utrecht Reformed Church replaced one built on the same site in 1699. The church was founded in 1677 as the fourth Dutch Reformed church in Kings County. In 1783, it became a symbol of American independence when residents flew a new American flag from its Liberty Pole to celebrate evacuation by the British troops. In 1790, George Washington visited the church.

The Brooklyn Hebrew Home and Hospital for the Aged, an East Flatbush institution founded in 1907, joined a Jewish system established to support the elderly and indigent. Seen here in 1939, the facility is now the Metropolitan Jewish Geriatric Center.

A major religious power in Brooklyn since 1823, the Baptists offered social services as well as a religious presence. Founded in 1869, the Baptist Home in the Fort Greene neighborhood supported the aged on limited incomes. In 1977, the Baptist Home of Brooklyn relocated upstate to Rhinebeck, New York.

Located in Brownsville and seen here in the heat of July 1939, the Betsy Head Play Center, a New York City Parks & Recreation property, contains a WPA-constructed bathhouse and an Olympic-sized pool.

In 1941, Freedom House, organized to counter threats to world democracy, held a celebrity-filled rally at Joseph Day's Manhattan Beach Baths. Tallulah Bankhead, at the microphone, Helen Hayes, and Mayor Fiorello La Guardia attended and spoke. Freedom House was founded by Eleanor Roosevelt, Wendell Wilkie, Dorothy Thompson, and George Field.

Looking north on Court Street in this 1942 *Brooklyn Eagle* photo, one can see the 1901 Temple Bar Building, the dark structure at left, and the pointed roof of the 1891 Brooklyn General Post Office in the distance beyond the trolley cars. Brooklyn Borough Hall is hidden at right.

Wallabout Market, named for Dutch Huguenots, was a city-supported, 45-acre public market established next to the Brooklyn Navy Yard on Wallabout Bay in 1884. Originally called Farmers' Square, it became the second-largest market in the world with the two-story Dutch-style brick buildings seen beyond the crowd in this 1940 view. A nighttime market, it served merchants displaced from Manhattan. Navy Yard expansion during World War II ended Wallabout Market.

Officially the Vechte-Cortelyou House of Gowanus, built in 1699 and named after the two seventeenth-century families who owned it, it is now known as the Old Stone House for its role in the Battle of Brooklyn. Commandeered by British artillery, the house was attacked by Maryland recruits, thereby allowing George Washington time to escape with his army. Subsequently a clubhouse for the original Brooklyn Dodgers, it was rebuilt in 1935 and is now a Park Slope museum for history pertaining to the Battle of Brooklyn.

Founded by German immigrants in 1857, Long Island College Hospital (LICH) created the country's first private bacteriological laboratory in 1888. By 1930, the Long Island College of Medicine incorporated as a separate medical school. Seen here in December 1941, LICH is today noted for its radiology and research programs and is the sixth-largest hospital in Brooklyn.

This 1941 view shows the F&M Schaefer Brewing Company processing beer in its Williamsburg bottling plant. Brooklyn's first distillery opened in 1819 on the Schaefer site. A later influx of German brewers in the 1880s included Trommer's beer and S. Liebmann's Rheingold beer. In 1949, a strike of brewery workers caused the collapse of Brooklyn's beer industry, and in 1976 Schaefer moved to Manhattan.

A public housing complex of 20 apartment buildings spread over 25 acres of playgrounds and gardens, Williamsburg Houses remains a model for municipalities. Established in 1938, this distinguished, first-ever venture of four-story buildings is lauded as the best public housing project ever built in New York and was given landmark status in 2003.

This scene is of a crowded Flushing Avenue during a Brooklyn Navy Yard strike of electrical workers in 1941, before the attack on Pearl Harbor put the Navy Yard on war footing.

With the onset of World War II, Brooklyn turned into a beehive of activity. Starting in 1940, the Board of Education hosted 45 training centers in vocational and training schools such as the National Youth Administration (NYA) work center seen in this 1942 photograph. Here, two bench workers receive training in machine shop practice.

In a training session at the Brooklyn Aviation Center in 1942, a student mechanic and an instructor work together on airplane wing sections.

Started in 1938 as housing for workers at Todd Shipyards and their families, and seen here four years later, Red Hook Houses became one of the largest housing projects in the city with over 7,000 residents.

In this 1942 domestic scene, Mrs. James Caputo pours milk for her children. They live in Red Hook Houses.

Here, in 1942, the Romano family enjoys dinner at home. Mr. Romano works at the Brooklyn Navy Yard.

Finnish settlers in Sunset Park called their neighborhood Pukin maki, or Goat Hill. Others called it Finn Town. Here in this neighborhood they established the first community of cooperative four-story apartments in 1916. After 1930, Finnish immigration slowed. In this 1942 picture, an officer is welcoming passersby to a Salvation Army hall in Finn Town.

With dancing and a WPA-built swimming pool, the Red Hook Recreation Center provided indoor and outdoor entertainment for residents. Here, in 1942, a big band performs at the center.

Jitterbugs "cut a rug" at a Red Hook Recreation Center party.

Public School 39, the Henry Bristow School, was established at 417 6th Avenue, at 8th Street. A fitting symbol for residents of Brooklyn's "Gold Coast," this 1877 mansarded Victorian school building in Park Slope is now a historic landmark.

With Brooklyn's population growing as a result of wartime jobs at the Todd Shipyards, residents of the Red Hook Houses enrolled in English classes. Here, an instructor teaches English at the Red Hook Recreation Center.

This church photographed in 1943 stood on 6th Avenue at 8th Street.

Bakers in a Finnish bakery in Sunset Park near 39th Street and 8th Avenue ply their trade in 1942. As with the apartment complexes there in Finn Town, the bakery is a cooperative.

Between 1942 and 1945, Manhattan Beach Baths turned into the Merchant Marine Training Center at Sheepshead Bay, the largest such center in the United States, where sailors for civilian supply ships were trained in six to eight weeks. Here, trainees are practicing the lowering of lifeboats. Kingsborough Community College now occupies the site.

These students are in the gymnasium for Berkeley Institute, a private preparatory school for girls that was founded in 1886 in Park Slope. Named after Irish philosopher George Berkeley, the school consolidated with Carroll School in 1982 to become Berkeley Carroll School, a co-educational institution with 750 students at three Park Slope locations.

Parents and their children attend a Sunday service in 1944 at a church identified as the Church of the Good Shepherd, though it should be noted several Brooklyn churches share that name.

Children make their way down the steps after Sunday School at the Church of the Good Shepherd.

These men are reviewing a Norwegian-American parade in Bay Ridge, May 17, 1944. Norwegians settled mostly in Bay Ridge after 1825, establishing homes, churches, social organizations, and hospitals. In the 1940s, they numbered about 55,000. The annual May parade celebrates Norway's Independence Day, also known as Constitution Day. Included on the reviewing stand are Dr. N. A. Rygg, publisher of the newspaper *Nordisk Tidende;* officers of the Royal Norwegian Navy and the United States Navy; and Pastor G. A. Storaker.

Brooklyn youngsters march in an Anniversary Day Parade in 1944. A church-related school holiday in Brooklyn to celebrate the founding of Brooklyn Sunday schools in 1816, Anniversary Day became an official New York State holiday (for schools but not banks) in 1861, with Sunday school parades as a feature. Today, it is Brooklyn-Queens Day, still a school holiday in those two boroughs.

Adjacent to the commercial port Bush Terminal in Sunset Park was the Military Ocean Terminal, established in 1918 and subsequently renamed the Brooklyn Army Terminal. A military ocean-supply facility, the terminal covered 97 acres. During World War II, a large percentage of the troops and 63 million tons of supplies for the United States war effort passed through the terminal. Piers 4 and 5 of the Brooklyn Army Terminal are seen here in 1947. In 1984, New York City purchased the site for small businesses.

A busy intersection of two major avenues, Flatbush and Church, in 1944 features two-story retail stores, billboards, pedestrians, automobiles, and crossing trolley tracks. Both streets served as the heart of commercial strips in a residential neighborhood of Flatbush.

At 6th Avenue and Berkeley Place in Park Slope, a policeman directs traffic while Sanitation Department workers clean up from a record snowfall of 26.4 inches that fell on Brooklyn, December 26–27, 1947.

Seen here in 1947, St. Martin de Tours Church on Hancock Street in Bedford-Stuyvesant was founded as a Roman Catholic parish in 1906. Its new name is St. Martin of Tours Fourteen Holy Martyrs.

The Metropolitan Avenue–Grand Street subway station in Williamsburg required draining after it was flooded in this scene from the late 1940s or 1950s. The station, part of the Independent (IND) crosstown line, opened in 1937.

As a promotion, Emil Gusto, who owned a tavern in Greenpoint, gave out 200 free tickets to a July 12, 1948, Dodgers' baseball game at Ebbets Field. Here, on July 3, crowds of boys reach for the tickets to the "Brooklyn vs. World" game.

In business since 1849, Pfizer, the mass producer of penicillin in World War II, and of Viagra and Lipitor since then, has been one of the longest-lasting Brooklyn firms. Its Flushing Avenue headquarters in Williamsburg, seen here about 1949, bolstered the neighborhood through community-conscious activism. In 2007, the Pfizer Company announced it was moving from Brooklyn but would continue to help the community by transforming the former administration building into a community center.

This Barton's candy store seen in 1949 was at 1706 Kings Highway. Established by George Klein in 1940, the Barton's franchise sold candies that were kosher. From his factory on DeKalb Avenue, Klein opened 50 stores around the city within a decade. He sold the franchise in 1981. The name is still used in a line of chocolates made in Allentown, Pennsylvania.

ON THE BRINK, ON THE RISE

(1950–1982)

Somehow, everything begins to slip and slide. Win some, lose some. In 1955, the Dodgers win the World Series, but in 1957, they depart for Los Angeles. The mighty Brooklyn waterfront goes into a slump. Container ships berth in New Jersey. Steeplechase closes. Theaters close. *Brooklyn Eagle* closes. Brooklyn Navy Yard closes. Schaefer Beer departs. Crime and graffiti increase. White flight paralyzes the borough.

Civil rights disturbances in Brooklyn lead to a decentralized school system. Robert Kennedy, neophyte New York senator, establishes Bedford-Stuyvesant Restoration Corporation.

A new bridge, the Verrazano-Narrows, curves over New York Bay from Brooklyn to Staten Island; Bay Ridge feels sacrificed, destroyed. A United Airlines plane collides with another over Staten Island and crashes in Park Slope. Only one survivor. For one day. Have we hit bottom yet?

But a glimmer flickers. Park Slope renovation and the community activism behind Cinderella Projects give hope. Vanderveer Estates provides middle-income housing, important for returning veterans, as is the opening of Veterans' Hospital in Dyker Beach. In Manhattan Beach, Kingsborough Community College starts classes in a former military base. So maybe things weren't so bad after all.

After the uncertainty of the 1970s, Brooklynites knew a better future was out there. Coney Island lost an annual parade called Mardi Gras in the 1950s, but in 1983, the Mermaid Parade replaced it. Brighton Beach revived with Russian pizzazz. The Landmarks Commission granted preservation status to several Coney Island icons.

Founded in 1995, Brooklyn Brewery harks back to the days when Greenpoint and Williamsburg boasted over 40 German breweries. Williamsburg, a former enclave for Lower East Side immigrants, now hosts art exhibitions. In place of the dying Brooklyn waterfront, Red Hook and Gowanus are changing into sleeping princesses with new business enterprises, cruise ship terminals, big-box stores, and a clear canal.

In 2001, professional baseball returned to Brooklyn as the Cyclones began playing in Keyspan Park. And the crème of this Brooklyn makeover: the 70-acre Brooklyn Bridge Park. Once more: Everything old is new again—in Brooklyn.

Seen here in 1951, the artificial harbor Erie Basin in Red Hook was created by William Beard in 1864. As the terminus of the Erie Canal, it had grain storage elevators and Todd dry docks for ship repair. In 1938, it was purchased by the NYC Port Authority.

In a protest against segregated schools, Claire Cumberbatch of Bedford-Stuyvesant led African American pupils, including her son, Larry, in the Pledge of Allegiance in September 1958. Protests such as this one led to school redistricting and integration and, eventually, decentralization of the school system.

This winter picture of the Promenade at Montague Street in Brooklyn Heights shows a 1950s Manhattan skyline across the East River. The one-third-mile pedestrian walkway between Remsen and Orange streets is counterlevered over three rows of traffic. Completed in 1950, it overlooks the future site of the waterside Brooklyn Bridge Park.

Founded in 1910, the Brooklyn Botanic Garden emerged from the site of a city dump and reservoir. Its 50 acres feature cherry trees, a Japanese garden, and the Steinhardt Conservatory. Near the northern Flatbush Avenue entrance is a City Line plaque indicating the border for the nineteenth-century city of Brooklyn.

Residents shop for produce at a pushcart market on Belmont Avenue in 1960. Pushcarts, a carryover from the Lower East Side, were always controversial due to sanitation issues. Mayor La Guardia banned them in 1938 in favor of indoor markets. Belmont Avenue in East New York, Brooklyn, had the same problem, but the indoor markets failed.

On December 16, 1960, a United Airlines airplane, off course and in a fog, collided with a TWA airplane over Staten Island. The United aircraft, its wreckage seen here, crashed into a brownstone roof at 7th Avenue and Sterling Place in Park Slope, killing 84 passengers and six people on the ground. More than 10 houses were destroyed, as was the Pillar of Fire church. In 2007, new houses replaced the destroyed ones.

The 1827 Ditmas–Van Nuyse House, a Dutch house built by Johannes Van Nuyse who married into the Ditmas family, was located on Amersfort Place. It was eventually purchased by Brooklyn College for a possible faculty club. When plans changed and no one volunteered to move it, the house was demolished in the 1960s for a college student center.

At a 1963 civil rights demonstration in Brooklyn, a participant is forcibly removed by police. Brooklyn, in 1963, led the city in civil rights protests organized by the Congress for Racial Equality (CORE). CORE organized for equality in housing and employment, and would join the famous March on Washington that year.

The flea market, a variation of the peddlers' market of East New York, became a protest against the high rental prices of the city-owned indoor markets. Seen here is the Brownsville flea market in 1962.

The functioning 1887 engine room of Pratt Institute's power plant serves as a museum of industrial archaeology, its generators still supplying a third of the campus with steam-driven electricity. With the oldest continually operating engine room in the country, the Clinton Hill college also offers an annual New Year's Eve celebration of steam whistles.

The Brooklyn Terminal Market in Canarsie replaced the earlier Wallabout Market in 1942 after the Brooklyn Navy Yard reclaimed the land on which the Wallabout stood. As demonstrated in this 1964 picture of a watermelon race, the Brooklyn Terminal Market deals in public wholesale produce.

Longshoremen load cargo at the Furman Street Pier in Brooklyn in 1967. Piers 1 through 12 on the Brooklyn waterfront were the heart of New York shipping in the 1950s and 1960s. The Brooklyn piers suffered with the advent of container ships, however, as New Jersey's waterfront could offer more room. Today, Piers 1–5 have been demolished in preparation for Brooklyn Bridge Park.

Robert F. Kennedy, elected senator from New York in 1964, and Donald F. Benjamin of the Central Brooklyn Coordinating Council are seen here with a group of children at a Brooklyn playground in February 1966. As senator, Kennedy initiated creation of the Bedford-Stuyvesant Restoration Corporation, which revitalized poor neighborhoods.

Opening in 1964, the Verrazano-Narrows Bridge was controversially named after Giovanni da Verrazzano (correct Italian spelling), who first sailed into New York Harbor in 1524. The two-deck suspension bridge was the last official project for Robert Moses, who wanted to name it simply the Narrows Bridge, and remains the largest suspension bridge in the country. In this later view, Brooklyn is at right, Manhattan is in the background.

Viewed here from the balcony during its final days, Brooklyn's Fox Theater on the corner of Flatbush Avenue and Livingston Street was a movie show palace built in 1929 by William Fox, who lived upstairs. The theater was also noted for its rock 'n' roll shows hosted by disc jockey Murray "the K" Kaufman in the 1950s.

Brooklyn's Fox Theater ran out of steam as a movie and concert hall and was demolished in 1971, as seen here in January that year, to be replaced by a Con Edison office complex.

In the 1970s, the boxing champion Muhammad Ali visited the campus of Kingsborough Community College in Manhattan Beach to promote black awareness. Here students and photographers surround him as he's about to make a speech.

This 1978 aerial view of Brooklyn Heights beyond the Brooklyn Bridge shows skyscrapers superimposed on the original Brooklyn settlement. Beyond is the most populous borough in New York City. Today, even more office buildings and condominiums fill the downtown vicinity.

Flatbush, one of the six original Brooklyn towns, was settled in 1652 in the center of the Dutch Midwout. The 1875 Flatbush Town Hall seen here was the heart of the independent town before it was annexed by the city of Brooklyn in 1894; now it serves as a community center.

Near the Bush Terminal in Sunset Park was the Navy's supply base for the various naval operations that operated around Brooklyn during World War I. On the other side of the Bush Terminal was the Army Supply Base. In the 1950s, the complex was operated by the Coast Guard. Storehouse No. 1 is pictured at rear-right.

This tower for a train switcher on the elevated section of the Brooklyn subways is located above Stillwell and Surf avenues in Coney Island. The building at right is the now defunct Shore Theater. On the other side of the street is Nathan's.

In the distance, the Brooklyn tower of the Verrazano-Narrows Bridge can be seen from a block on Shore Parkway. Bay Ridge, which includes this block, was the neighborhood most affected by the project, with families displaced and homes demolished for the bridge approaches.

This view shows the Stillwell Avenue elevated station that leads to Coney Island. In 2004, the platforms and entrances were rebuilt.

This Stillwell Avenue entrance to the elevated trains was created in 1923 to service the millions who thronged to Coney Island's beach. To its right had been Luna Park, with Steeplechase further down Surf Avenue. In the center of the facade was Philips Candy Store with candy made by John Dorman. In 1999, the entrance was demolished for a new 2004 entrance.

An entrance to what is now DUMBO—Down Under the Manhattan Bridge Overpass—at Front Street and Cadman Plaza, this block of the Fulton Ferry Historical District was the hub of pre-bridge ferry traffic. At left in this 1982 view, the former Long Island Safe Deposit Company building, completed in 1869, is now a restaurant. Above stands the Brooklyn Bridge tower.

In this view east from the Brooklyn tower of the Brooklyn Bridge, the 1909 Manhattan Bridge spans the East River, with the Williamsburg Bridge in the distance. A workman is walking up the cable.

When the Brooklyn Bridge opened in 1883, it was illuminated with 70 arc lights. Now, its "necklace" of lights is energy-efficient "green," but they also can change colors.

Notes on the Photographs

These notes, listed by page number, attempt to include all aspects known of the photographs. Each of the photographs is identified by the page number, photograph's title or description, photographer and collection, archive, and call or box number when applicable. Although every attempt was made to collect all available data, in some cases complete data was unavailable due to the age and condition of some of the photographs and records.

II	**Brooklyn Bridge** New York State Archives NYSA_A3045-78_D47_NB1	5	**Charles Pfizer and His Family** Brooklyn Historical Society V1986.248.11	10	**Washington Street** Brooklyn Museum/Brooklyn Public Library—Brooklyn Collection BRAI 0304	14	**Boys Sliding on Tin Cans** Brooklyn Museum/Brooklyn Public Library—Brooklyn Collection BRAI 0243
VI	**Brooklyn City hall** Library of Congress LC-USZ62-73187	6	**Columbia Street** Brooklyn Museum/Brooklyn Public Library—Brooklyn Collection BRAI 0346	11	**Brooklyn Bridge in Distance** New York State Archives NYSA_A3045-78_D47_NA6	15	**Columbia Street** Brooklyn Museum/Brooklyn Public Library—Brooklyn Collection BRAI 0313
X	**Walking Across Brooklyn Bridge** Library of Congress LC-USZ62-133262	7	**The Inexhaustible Cow** Library of Congress LC-USZ62-53845	12	**Man in Rowboat in Erie Basin** Brooklyn Museum/Brooklyn Public Library—Brooklyn Collection BRAI 0335	16	**Brighton Beach Hotel on Rails** Library of Congress LC-USZ62-53843
2	**Horse and Carriage** Brooklyn Historical Society V1972.1.827	8	**Coney Island Bathers** Brooklyn Museum/Brooklyn Public Library—Brooklyn Collection BRAI 0367	13	**Train on Brooklyn Bridge** Brooklyn Museum/Brooklyn Public Library—Brooklyn Collection BRAI 0338	18	**Letter Carrier at Christmas** Brooklyn Museum/Brooklyn Public Library—Brooklyn Collection BRAI 0223
3	**Walt Whitman's Carpenter Shop** Library of Congress LC-USZ62-105151	9	**Construction of Brooklyn Bridge** Library of Congress LC-USZ62-104448				
4	**Bay Ridge House** New York State Archives NYSA_A3045-78_D47_BrY2						

201

19 **Sheepshead Bay Race Track**
Brooklyn Museum/Brooklyn Public Library—Brooklyn Collection
BRAI 0294

20 **Prospect Park Drinking Fountain**
Library of Congress
LC-USZ62-114518

21 **Old Sailor with Ship Model**
Brooklyn Museum/Brooklyn Public Library—Brooklyn Collection
BRAI 0303

22 **Walt Whitman**
Brooklyn Public Library—Brooklyn Collection
POST 0198

23 **Coal Shoveler**
Brooklyn Museum/Brooklyn Public Library—Brooklyn Collection
BRAI 0340

24 **Swabian Society Picnic in Prospect Park**
Brooklyn Museum/Brooklyn Public Library—Brooklyn Collection
BRAI 0331

25 **Family on Coney Island Beach**
Brooklyn Museum/Brooklyn Public Library—Brooklyn Collection
BRAI 0361

26 **Columbia Heights**
Brooklyn Museum/Brooklyn Public Library—Brooklyn Collection
BRAI 0310

27 **Skating Chair**
Brooklyn Museum/Brooklyn Public Library—Brooklyn Collection
BRAI 0317

28 **Fulton Ferryboat**
Library of Congress
LC-DIG-ppmsca-07542

29 **Launching of USS Maine**
Library of Congress
LC-USZ62-67361

30 **Green-Wood Cemetery**
Library of Congress
LC-DIG-ggbain-09030

31 **Machine Gun at Brooklyn Navy Yard**
Library of Congress
LC-D4-21273

32 **Brooklyn Navy Yard Hospital**
Library of Congress
LC-D4-21261

33 **Talmage's Tabernacle after Fire**
Brooklyn Museum/Brooklyn Public Library—Brooklyn Collection
THOM 0016

34 **Bathers in the Surf**
New York State Archives
NYSA_A3045-78_D47_BrY69

35 **Beach at Norton's Point**
New York State Archives
NYSA_A3045-78_D47_BrY75

36 **Boys' High School**
New York State Archives
NYSA_A3045-78_D47_BrP6

37 **Kings County Penitentiary**
Brooklyn Museum/Brooklyn Public Library—Brooklyn Collection
THOM 0007

38 **P. T. Barnum Circus**
Brooklyn Museum/Brooklyn Public Library—Brooklyn Collection
THOM 0092

39 **Dedication of Grant Monument**
Brooklyn Public Library—Brooklyn Collection
THOM 0006

40 **Brooklyn Bridge**
Library of Congress
LC-USZ62-100441

42 **Submarine Boat**
Library of Congress
LC-USZ62-57113

43 **Floral Ship Tribute**
Library of Congress
LC-DIG-ggbain-19242

44 **On the Promenade**
Library of Congress
LC-USZ62-97318

46 **5th Avenue and Flatbush Intersection**
Kingsborough Historical Society/Library of Congress

47 **St. George Hotel**
Library of Congress
LC-D4-19077

48 **Entrance to Prospect Park**
Library of Congress
LC-D4-16938

49 **Henry Ward Beecher Statue**
Library of Congress
LC-D4-16937

50 **Pneumatic Mail Tubes**
New York State Archives
NYSA_A3045-78_D47_BrP2

51 **Prospect Park in Winter**
Library of Congress
LC-USZ62-62305

52 **Skating Club**
Library of Congress
LC-DIG-ggbain-00162

53 **Williamsburg Bridge**
Library of Congress
LC-D4-14748

54 **Dreamland, Coney Island**
Kingsborough Historical Society/Library of Congress
LC-2264-C1-45

55 **Brooklyn Institute of Art and Science**
Library of Congress
LC-D4-16935

56 **Brooklyn Museum**
Library of Congress
LC-d4-39848

57 **Historic Bergen House**
Library of Congress
HABS NY, 24-BROK, 13

58 **Shamrock III in Dry Dock**
Library of Congress
LC-D4-21758

59 **Brooklyn Navy Yard, Sands Street Entrance**
Library of Congress
LC-D4-21814

60 **Fireworks at Opening of Williamsburg Bridge**
Library of Congress
LC-USZ62-63524

61 **Soldiers and Sailors Memorial**
Library of Congress
LC-D4-33247

62 **Brooklyn Bridge Transportation**
Library of Congress
LC-D4-36498

63 **Harbor of New York with Bridges**
Library of Congress
LC-USZ62-6211

64 **Ships Docked in Brooklyn Navy Yard**
Library of Congress
LC-USZ62-66021

65 **Igarotes at Coney Island**
Library of Congress
LC-USZ62-73201

66 **Borough Hall**
Library of Congress
LC-USZ62-98896

67 **Lincoln Statue**
Library of Congress
LC-USZ62-102557

68 **New Montauk Theatre**
Library of Congress
LC-D4-19291

69 **Entrance to Green-Wood Cemetery**
Library of Congress
LC-USZC4-1836

70 **Pratt Institute**
Library of Congress
LC-D4-19293

71 **Children's Reading Room**
Library of Congress
LC-USZ62-48867

72 **Post Office and Brooklyn Eagle Buildings**
Library of Congress
LC-D4-19292

73 **Long Island Rail Road Terminal**
Library of Congress
LC-D4-500204

74 **Policemen with William Jennings Bryan**
Library of Congress
LC-DIG-ggbain-00078

75 **Brooklyn Union League Club**
Library of Congress
LC-D4-19295

76 **James Simcox**
Library of Congress
LC-DIG-ggbain-00483

77 **Luna Park at Night**
New York State Archives
NYSA_A3045-78_D47_BrY721

78 **Girls' High School**
Library of Congress
LC-D4-500203

79 **Police Traffic Squad**
Library of Congress
LC-DIG-ggbain-00485

80 **Newsie on Brooklyn Bridge**
Library of Congress
LC-DIG-nclc-03667

81 **Borough Hall Subway Entrance**
Library of Congress
LC-USZ62-92622

82 **Women Sewing American Flags**
Library of Congress
LC-USZ62-70761

83 **Fans Outside Park on Baseball Opening Day**
Library of Congress
LC-DIG-ggbain-00308

84 **Open-air Mass**
Library of Congress
LC-DIG-ggbain-00479

85 **Shopping on Fulton Street**
Library of Congress
LC-DIG-nclc-04626

86 **Brooklyn Marathon**
Library of Congress
LC-USZ62-111275

87 **James Crowley, Brooklyn Marathon**
Library of Congress
LC-DIG-ggbain-03148

88 **Williamsburg Bridge on Rosh Hashanah**
Library of Congress
LC-USZ62-72470

89 **Dr. Frederick Cook Tribute**
Library of Congress
LC-USZ62-120193

90 **Scottish Bagpiper**
Library of Congress
LC-USZ62-85318

91 **Brighton Beach Motordrome and Manhattan Beach**
Library of Congress
LC-USZ62-74645

92 **Family Making Brushes**
Library of Congress
LC-H5-2827

93 **Blind Man Making Toys**
Library of Congress
LC-USZ62-1113565

94 **Ebbets Field Opening Day**
Library of Congress
LC-DIG-ggbain-12804

96 EBBETS FIELD
Brooklyn Historical Society
V1948.1.645

97 CASEY STENGEL
Library of Congress
LC-USZ62-71745

98 THEODORE ROOSEVELT INSPECTING CITY WORKSHOP
Library of Congress
LC-USZ62-49351

99 ATLANTIC AVENUE SUBWAY ENTRANCE
Library of Congress
LC-D4-72144

100 BETHANY DEACONESS HOSPITAL
Library of Congress
HABS NY,24-BROK, 47

101 CONEY ISLAND
Kingsborough Historical Society/Library of Congress
LC-USZ62-83226

102 PRESIDENT WILSON AT BROOKLYN NAVY YARD
Library of Congress
LC-USZ62-90822

103 14TH AND NEW UTRECHT AVENUES
Brooklyn Public Library—Brooklyn Collection
RUTT0128

104 VIEW OF REAR YARDS IN WILLIAMSBURG
Brooklyn Public Library—Brooklyn Collection
RUTT0134

105 PROSPECT PARK WEST
Brooklyn Public Library—Brooklyn Collection
NEIG 1720

106 UNLOADING AT BUSH TERMINAL
Brooklyn Public Library—Brooklyn Collection
RUTT 0045

107 BUSH TERMINAL RAILROAD
Brooklyn Public Library—Brooklyn Collection
RUTT 0055

108 DUPONT STREET PIER
New York State Archives
PPO File Folder #174

109 1 MONROE PLACE
Brooklyn Public Library—Brooklyn Collection
NEIG 0180

110 DANCING ON BRIGHTON BEACH
Kingsborough Historical Society/Library of Congress
LC-B2-3134-12

111 BEACH NEAR STEEPLECHASE
Kingsborough Historical Society/Library of Congress
LOC-517240

112 FORMER BROOKLYN CHILDREN'S COURT
Brooklyn Public Library—Brooklyn Collection
RUTT 0031

113 ATLANTIC AVENUE
Brooklyn Public Library—Brooklyn Collection
RUTT 0095

114 CALVIN COOLIDGE AND BROOKLYN CHAMBER OF COMMERCE
Library of Congress
LC-USZ62-111706

116 BREAD LINE
Library of Congress
LC-USW33-0591-C

117 JOHN MCCOOEY THROWS OUT FIRST BASEBALL
Library of Congress
LC-USZ62-116251

118 PLYMOUTH CHURCH OF THE PILGRIMS
Library of Congress
HABS NY,24-BROK,31-2

119 INTERIOR OF PLYMOUTH CHURCH OF THE PILGRIMS
Library of Congress
HABS NY,24-BROK,31-3

120 BROOKLYN BRIDGE
New York State Archives
Brooklyn Bridge

121 7TH AVENUE AND CARROLL STREET
Brooklyn Public Library—Brooklyn Collection
NEIG1725

122 BROOKLYN EDISON COMPANY BUILDING
Library of Congress
LC-USZ62-123191

123 FIRE IN WAREHOUSE
Library of Congress
LC-USF344-000881-ZB

124 CUPOLA ON BOROUGH HALL
Library of Congress
HABS NY,24-BROK,42-6

125 APPRENTICE TAILORS
New York State Archives
Clothing Worker Trainees

126 GREEN POINT SAVINGS BANK
Brooklyn Museum/Brooklyn Public Library—Brooklyn Collection
UNDE 0124

127 SUBWAY TRAIN IN SCHERMERHORN STATION
New York State Archives
NYSA_A3045_B17263

128 SCHENCK HOUSE IN CANARSIE
Library of Congress
HABS NY,24-BROK,18-3

129 DR. JAMES TILLARY HOUSE
Library of Congress
HABS NY,24-BROK,35-1

130 TRAFFIC LANES CONVERGE
New York State Archives
NYSA_A3045-78_Dn_BtC9

131 GRANADA HOTEL
Library of Congress
LC-G612-T-36200

132 NEW UTRECHT REFORMED CHURCH
Library of Congress
HABS NY,24-BROK,50-1

133 Hebrew Home and Hospital for the Aged
Library of Congress
LC-G613-T-36199

134 Baptist Home
Library of Congress
HABS NY,24-BROK,58-15

135 Betsy Head Play Center
Library of Congress
LC-G612-T-35524-B

136 Actress Tallulah Bankhead at Rally
Herman Field
Kingsborough Historical Society

137 Court Street
Brooklyn Public Library—Brooklyn Collection
NEIG 1223

138 Wallabout Market
Library of Congress
LC-DIG-ppmsca-12738

140 Old Stone House
Library of Congress
HABS NY,24-BROK,40-2

141 Long Island College Hospital
Library of Congress
LC-G612-T-41503

142 F&M Schaefer Brewing Company Production Line
Library of Congress
LC-G612-T-39322

143 Williamsburg Houses
Library of Congress
LC-G612-T-40807

144 Electrical Workers Strike
Library of Congress
LC-USZ62-124542

145 Wartime Workers
Library of Congress
LC-USW3-053770-E

146 Training at Aviation Center
Library of Congress
LC-USE6-5476

147 Red Hook Housing Project
Library of Congress
LC-USW3-4602-D

148 Red Hook Domestic Scene
Library of Congress
LC-USW3-4857-D

149 Family Enjoys Dinner
Library of Congress
LC-USW3-13446-D

150 Salvation Army in Finn Town
Library of Congress
LC-USW3-09836-E

151 Band Performing at Red Hook Center
Library of Congress
LC-USW3-4882-D

152 Dancing in Red Hook
Library of Congress
LC-USW3-4885-D

153 Henry Bristow School
Library of Congress
LC-G613-T-44377

154 English Class
Library of Congress
LC-USW3-4890-D

155 Church on 6th Avenue
Library of Congress
LC-G613-T-44375

156 Finnish Bakery
Library of Congress
LC-USW3-009838-E

157 Lifeboat Davits
Library of Congress
LC-USW33-026140-C

158 Berkeley Institute
Library of Congress
LC-G612-T-43394A

159 Service at the Church of the Good Shepherd
Library of Congress
LC-USW3-043519-C

160 Children Leaving Sunday School
Library of Congress
LC_USW3-043495-E

161 Norwegian-American Parade in Bay Ridge
Library of Congress
LC-USW3-42602

162 Anniversary Day Parade
Library of Congress
LC-USW3-043479-E

163 Peirs 4 and 5 at Army Terminal
Library of Congress
HABS NY,24-BROK,53D-17

164 Flatbush and Church Avenues
Library of Congress
LC-G613-T-46454

165 Clearing Record Snowfall in Park Slope
Brooklyn Public Library—Brooklyn Collection
NEIG 1729

166 Interior of St. Martin de Tours Church
Library of Congress
LC-G612-T-50658

167 Flooded Subway Station
Brooklyn Public Library—Brooklyn Collection
TRAN 0302

168 Free Tickets to Dodgers Game
Brooklyn Public Library—Brooklyn Collection
EAGL 0002

169 Pfizer Administration Building
Brooklyn Historical Society
V1986.248.1

170 Barton's Candy Store
Library of Congress
LC-G613-T-54972

172 Erie Basin
New York State Archives
NYSA_B1598-99_B4F11_51-2530

174 Pledge of Allegiance
Library of Congress
LC-USZ62-134433

175 **Brooklyn Heights Promenade**
Brooklyn Public Library—Brooklyn Collection
NEIG 0217

176 **Entrance to Brooklyn Botanic Garden**
Brooklyn Public Library—Brooklyn Collection
HERZ 0216

177 **Pushcart Market**
Library of Congress
LC-DIG-ppmsca-12709

178 **United Airlines Crash in Park Slope**
Brooklyn Public Library—Brooklyn Collection
HERZ 0222

179 **Ditmas–Van Nuyse House**
Library of Congress
HABS NY,24-BROK,3-6

180 **Civil Rights Demonstration**
Library of Congress
LC-USZ62-134715

181 **Brownsville Flea Market**
Library of Congress
LC-DIG-ppmsca-12708

182 **Pratt Power Plant**
Library of Congress
HABS NY-24-BROK,52A-1

183 **Watermelon Race**
Library of Congress
LC-DIG-ppmsca-12756

184 **Longshoremen Loading Cargo**
Library of Congress
LC-USZ62-124237

185 **Robert F. Kennedy**
Library of Congress
LC-USZ62-133299

186 **Verrazano-Narrows Bridge**
Library of Congress
HAER NY,24-BROK,57-3

187 **Fox Theater Stage and Proscenium**
Library of Congress
HABS NY,24-BROK,41-12

188 **Demolition of Fox Theater**
Library of Congress
HABS NY,24-BROK,41-23

189 **Muhammad Ali**
John Rossi
Kingsborough Historical Society

190 **Brooklyn Bridge and Brooklyn Heights**
Library of Congress
HAER NY,31-NEYO,90-9

192 **Flatbush Town Hall**
Library of Congress
HABS NY,24-BROK,43-1

193 **Storehouse No. 1**
Library of Congress
HAER NY,24-BROK,56-2

194 **Switching Tower**
Library of Congress
HAER NY-325

195 **Verrazano-Narrows Bridge Tower**
Library of Congress
HAER NY,24-BROK,57-18

196 **Stillwell Avenue Elevated Platform**
Library of Congress
HAER NY-325-19

197 **Stillwell Avenue Entrance**
Library of Congress
HAER NY-325-11

198 **Bank Building and Brooklyn Bridge Tower in DUMBO**
Library of Congress
HAER NY,31-NEYO,90-29

199 **View from Top of Brooklyn Bridge Tower**
Library of Congress
HAER NY,31-NEYO,90-38

200 **Brooklyn Bridge Lighted**
Library of Congress
HAER NY,31-NEYO,90-22